A PRACTICAL GUIDE TO
AIRBRUSHING

A PRACTICAL GUIDE TO
AIRBRUSHING

ANDY CHARLESWORTH

DRAGON'S WORLD

Dragon's World Ltd
Limpsfield
Surrey RH8 0DY
Great Britain

First published by Dragon's World 1990

Project Editor Jack Buchan
Designer Tom Deas
Editorial Director Pippa Rubinstein

British Library Cataloguing in Publication Data

Charlesworth, Andy
 A practical guide to airbrushing
 1. Airbrushing. Techniques
 I. Title
 751.4'94

ISBN 1 85028 065 7 (hardback)
 1 85028 066 5 (limpback)

Typeset by Bookworm Typesetting

Printed in Spain

CONTENTS

INTRODUCTION

Airbrush art has been in the forefront of the world of graphics and illustration for the last 50 years or so. Originally, around the turn of the century, the airbrush was used mainly for lettering and purely graphic work. Then, during the 1930s and 1940s, the airbrush came to the fore through the work of artists such as Vargas and George Petty, whose airbrushed pin-up girls were enormously popular and firmly established airbrushing as a serious creative technique. In recent years, airbrush artists have exhibited their work in galleries alongside paintings by traditional painters. The airbrush has definitely come of age.

The more you study airbrush techniques, the more you begin to notice examples of professional airbrushing in books and magazines, on posters and advertisements. Once you are familiar with the effects of the airbrush, you will observe that many advertising photographs have been subtly improved with an airbrush, and that there are a large number of pure airbrushed illustrations used for magazine covers and for glossy promotional brochures. The skill needed to produce top-quality work for publication may take years to achieve, but remember that every professional airbrush artist once picked up an airbrush for the first time and began to explore its possibilities.

Many artists discover the airbrush by accident, try it out, then get hooked, because only the airbrush is capable of reproducing tonal gradations with almost photographic precision, making possible a complete range of effects, from smooth, perfect skin in photo-realistic portraits to the hard, cold glint of chrome in space-age fantasy art. A skilled airbrush artist can produce an artwork which bears comparison with any traditional work of art in terms of imagination, skill and artistic expression. At the same time, a complete newcomer to airbrushing, after only a few hours' practice, can create realistic three-dimensional effects and well-controlled washes of colour.

Right: *The popularity and fame of the airbrush surged forward during the 1930s and 1940s when pin-up girls, airbrushed by artists such as Petty and Vargas, started to appear regularly in magazines. Although this pin-up illustration, by Tom Stimpson, is in the same style, it is definitely more revealing than the earlier artworks.*

Right: *The almost limitless capabilities of the airbrush make it a favourite tool with artists who specialise in science fiction illustrations. In this artwork, Andrew Stewart has combined a realistic landscape setting with an imaginative, futuristic scene. The starburst highlights in the sky create an even stronger science fiction effect.*

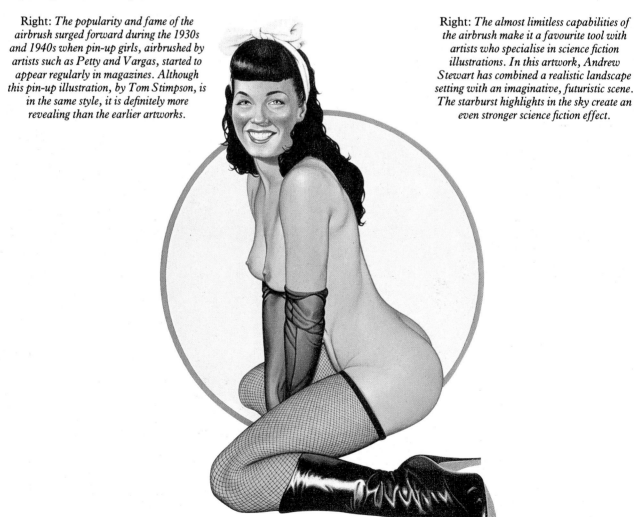

Left: *The airbrush is ideal for creating flat washes of colour and smoothly graduated tones. Gavin McCleod laid down the basic broad areas of colour with an airbrush, then added much of the detail with a sable brush. The blue of the car's bodywork is almost even in tone, while the gold letters and the black of the tyres flow smoothly from light to dark.*

Right: *This illustration combines a number of techniques. Brian James airbrushed most of the artwork in ink, but the grains on top of the hamburger were sable brushed. He used liquid masking for the texture of the meat and scratched out the details of the onions with a blade. Finally, the lettering was typeset and added to the finished artwork.*

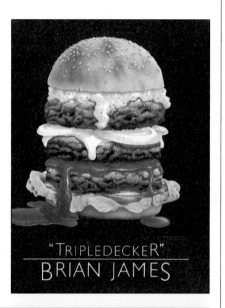

SETTING UP THE STUDIO

Whether you work in a purpose-built studio or in your own home, it is important that you have adequate space in which to work and that the area is tidy and uncluttered at all times: it is surprising to what degree an untidy environment can adversely affect your work.

A proper drawing board is the ideal surface on which to work, but a good-sized table or desk will suffice. It helps to have a set of shelves so that jars of paint, pencils, rulers and so on can be stored away from the work area itself. Many an artwork has been ruined when a jar of colour has been carelessly put down and accidentally knocked over.

VENTILATION

Adequate ventilation is very important in an airbrush studio, as an airbrush puts a lot of atomized paint into the air and you run the risk of breathing it in. Certain colours, such as those that contain cadmium, are toxic, and some thinners give off noxious fumes. Opening a window is not the best solution as it causes draughts and can let in dust which may contaminate your work. An extractor fan is preferable, but if this is not possible you can use a special spray filter, which sucks air in and purifies it. Filters of this type are purpose-made for airbrushing, and they fit onto the drawing board without inconveniencing the artist. Some larger models have a top and sides which partly enclose the work area, making them more effective at catching the spray in the air.

Another way to avoid breathing in the spray is to wear a face mask, which traps most of the spray in a disposable fabric filter.

LIGHTING

Natural light from a north-facing window is the accepted ideal for most artists, but inevitably you will have to work under artificial lights, too. Many artists use daylight fluorescent tubes for general illumination, supplemented by angled lamps focused on the actual work area.

CHOOSING AN AIRBRUSH

The first airbrush was patented in Britain by the artist Charles Burdick in 1893. Today's airbrushes are more streamlined and technologically advanced, but the basic design principles have changed little since that time. Air is forced under pressure through a narrow channel inside the airbrush and out through the nozzle. The partial vacuum created at the nozzle ensures that the paint flows from the reservoir, mixes with the stream of air and is atomized. The spray which is produced passes through a nozzle on to the surface being sprayed. An adjustable needle running through the body of the brush controls the flow of the medium: when the needle is pulled back

An independent double-action airbrush with a side-mounted colour reservoir. A reservoir which is mounted in this way can be quickly removed and exchanged for another one which contains a different colour, making it easy for the artist to work with a variety of tones. The only drawback with this type of reservoir when you are doing fine work is it can get in the way.

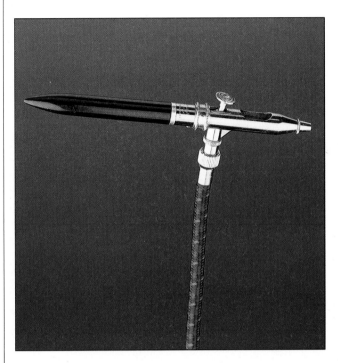

For finely detailed work, many artists prefer an airbrush which has its colour reservoir built into the body. This airbrush will hold only a small amount of paint, but it is light to handle and can be held very close to the surface that is being sprayed. Any colour remaining in the reservoir needs to be cleaned out before a new colour is used.

from the nozzle, in a double-action airbrush, more paint is drawn into the air stream. Ideally the spray from the airbrush should be completely even. The various types of airbrush on the market give different degrees of control over the flow of air and over the amount of paint that is mixed with the air.

When buying an airbrush, it is worth selecting a make and model for which spare parts are easily available. Ask your suppliers where your model can be sent for servicing, or write to the manufacturer for advice.

There are two main categories of airbrush: single-action models, which let you control only the air supply, and double-action models, which allow you control over both the air and paint supply. With both types the control is a trigger situated on top of the body, which you operate with your index finger.

SINGLE-ACTION AIRBRUSHES

The most basic type of airbrush is the single-action type. The trigger turns on the flow of air and paint through the airbrush, but does not give any control over the ratio of air to paint while the airbrush is in use, because the trigger does not make the needle move. Nor does it control the amount of air drawn into the airbrush – it is either on or off. When you press the trigger down, it switches on the air supply and paint is immediately drawn into the air flow and sprayed on to the surface you are working on. The spray produced is conical in shape, so the further from the surface you hold the airbrush, the wider the spray pattern will be.

Similarly, the only way to control the density of the spray from a single-action airbrush while you are actually spraying is to vary the distance between the airbrush and the support – the greater the distance, the finer the spray. Some single-action airbrushes allow you to pre-set the amount of air that is admitted to the airbrush when the trigger is pressed, giving a choice of density of spray. The air jet can be adjusted on some models so that you can control the spray pattern, as well as the needle which controls the amount of paint fed into the air stream.

The simplest kind of single-action airbrush works on an external mix principle: the jet of air from the airbrush blows across the end of the tube which supplies the paint and draws the paint into the air stream. This method of operation does not always cause the paint to atomize completely, and the spray can sometimes be rather coarse. To overcome this problem, other single-action models use internal mixing, in which the paint is drawn into the body of the airbrush and mixed with the air as it flows through the airbrush itself. This results in better atomization and a more even spray.

All in all, the single-action airbrush is fine for spraying flat colours, but it offers a limited range of possibilities to the artist, particularly in finely detailed work.

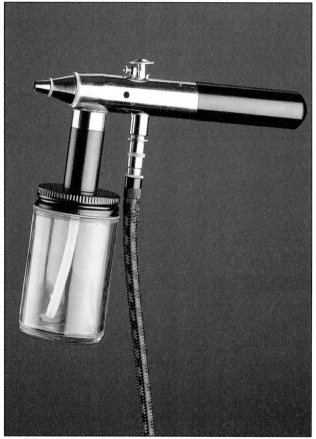

This kind of large-scale airbrush is ideal for jobs which involve spraying broad areas of flat colour, such as painting stage scenery or murals. The colour jar holds enough paint to cover a wide area and cannot spill, so the airbrush can be used at almost any angle. The independent double-action design still allows complete control of the spray.

FIXED DOUBLE-ACTION AIRBRUSHES

There are not many fixed double-action airbrushes on the market, but they offer advantages over the single-action variety. The flow of paint and air is controlled by a single lever. Pressing the lever down increases the flow through the airbrush, but the ratio of paint to air cannot be varied while the airbrush is in use. This means that the spray is reliable and even, but the artist cannot vary its density, although some designs allow you to pre-set the ratio of paint to air before you begin spraying.

With a fixed double-action airbrush, you can spray a fine line by holding the airbrush close to the surface and using a small amount of air. At the other extreme, you can hold the airbrush further away, turn the air on full and spray a broad area of colour.

INDEPENDENT DOUBLE-ACTION AIRBRUSHES

The top-of-the range airbrush is the independent double-action type. This is the airbrush favoured by professional artists, because it produces all the amazing finishes and effects for which airbrush illustration is so admired. This design gives complete control over the amount of air flowing through the brush, and the amount of colour which it sprays. The trigger moves in two directions – downward to increase the amount of air, and backward to increase the amount of paint drawn into the air stream. Once your finger has got used to the sensitivity of the trigger, you can constantly vary these two quantites, changing from dense, solid colour to a misty wash in a single sweep of the airbrush.

NEW DEVELOPMENTS

Airbrush design has traditionally been very conservative, with designs being altered slowly over the years, rather than dramatically different designs taking their place. Recently, however, every part of the airbrush was looked at critically when the Aztec was designed. The Aztec has interchangeable needle and nozzle assemblies which protect the needle from damage. Basically, it is an independent double-action airbrush, but it can be adjusted so that it performs as a fixed double-action model.

RESERVOIRS

All airbrushes have a container to hold a supply of the medium being fed through them. There are two ways in which the medium is fed into the airbrush: suction feed and gravity feed. Suction-feed models have a reservoir below the body of the airbrush, from which paint is drawn up. The advantages of this type are that it has a large fluid capacity, and because the reservoir is screwed or fitted to the body of the airbrush, colours can be interchanged quickly and easily. The disadvantage is that the reservoir gets in the way for close, finely detailed

The Aztec airbrush was designed from scratch after every part of the traditional airbrush had been evaluated critically. Notable features include the integral nozzle and needle assembly, and the roller in the body which can be adjusted to make the Aztec behave either as a fixed double-action design or as an independent double-action airbrush.

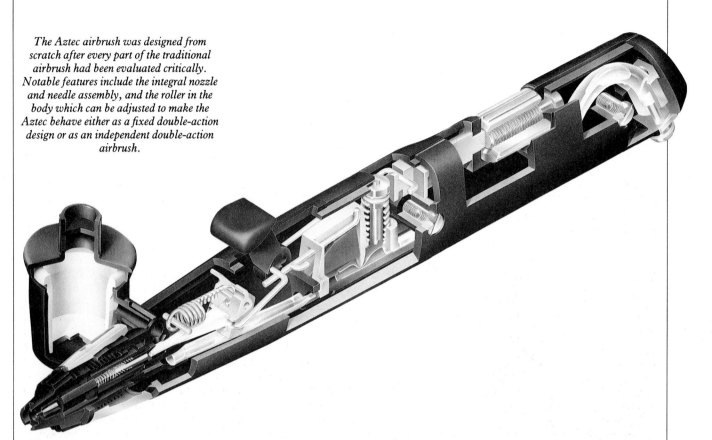

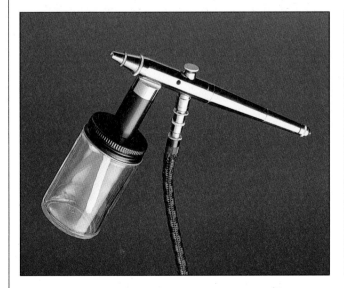

This airbrush works on the single-action principle – the lever brings in the air and the paint together but you cannot control the ratio of paint to air while you are spraying. Many model makers use airbrushes like this, but professional illustrators and graphic artists favour the independent double-action airbrush.

The Aztec can be bought as a complete kit, housed in a carrying case, containing the airbrush itself, two nozzle/needle assemblies, two colour cups, a funnel, an airline and a compressor adaptor – in fact, all of the equipment you need to begin airbrushing apart from a compressor and some paint!

work, and it makes the airbrush unbalanced and cumbersome in use.

With gravity-feed airbrushes the reservoir is either on top or to one side of the airbrush body, and gravity aids the flow of paint to the nozzle. These have a more limited liquid capacity than the suction-feed type, and the reservoir is often inseparable from the body of the airbrush, which means that they must be cleaned out thoroughly and refilled each time the colour is changed. However, they are better balanced and easier to manipulate.

CHOOSING A COMPRESSOR

The choice of compressor is just as important as the choice of airbrush. If you intend doing a lot of airbrushing, it is worth investing in a good quality compressor at the outset: you will probably still be using the same compressor in a few years' time, even though you may have changed your airbrush several times. It helps enormously if your compressor runs quietly – a noisy compressor is distracting and will make you unpopular with your family and neighbours.

A good compressor should have three important features: moisture trap, pressure regulator and pressure gauge.

DIAPHRAGM COMPRESSORS

The simplest and cheapest type of compressor works on the diaphragm principle. There is no air storage tank, but an electric motor pumps air directly into the air hose. As it does so it produces an uneven, pulsing air flow which may cause inconsistent lines and patchy areas of colour when you spray. Another problem is that a moisture trap and regulator are not usually incorporated, so water vapour from the compressed air condenses inside the air hose and airbrush. Water condensation can spoil your artwork by affecting the spray consistency.

STORAGE COMPRESSORS

More expensive, but more sophisticated, is the storage compressor. This design pumps air into a storage tank, from where it is drawn into the air hose, past a moisture trap, to the airbrush. Storage compressors provide a constant supply of non-pulsing, moisture-free air at a constant but adjustable pressure. In the most expensive versions, the motor automatically cuts out when the pressure in the tank reaches the desired pre-set level, and starts up again when the pressure in the tank drops below a certain level. This means that the compressor is quieter in use and runs for long periods without overheating. Storage compressors are available in a range of sizes, from those which drive a single airbrush up to those which are capable of powering several airbrushes at a time.

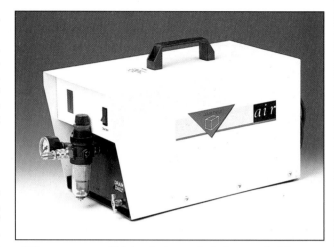

This compressor, which is priced towards the lower end of the range, would serve all of the needs of the serious amateur and is also suitable for intermittent professional use. It incorporates a moisture trap and a pressure control valve. Its built-in reservoir delivers a steady stream of pulse-free air to the airbrush.

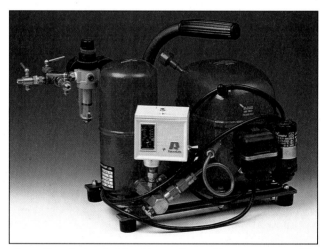

A small professional airbrushing studio would use a compressor like this. Its motor is designed to run continuously for long periods, and it has outlets to supply compressed air to three airbrushes at once. It runs very quietly and operates automatically – the motor cuts in again when the pressure in the reservoir falls to a pre-set figure.

*Once you have bought an airbrush and a compressor, the rest of the
equipment for the studio is quite inexpensive. A good cutting mat is a
great asset, and a supply of sharp blades makes life much easier.
The airbrush artist can choose from numerous types of paper, all
with different qualities and textures.*

Compressors should be serviced regularly and given a safety check. Those with pistons should have their oil level checked at regular intervals.

STUDIO EQUIPMENT

Apart from the airbrush and compressor, there are many other items of equipment which the well-equipped studio should contain. A surgical scalpel and a top-quality craft knife are essential to the airbrush artist, as masks need to be cut very cleanly and precisely. Keep a supply of spare scalpel blades so that you always have a sharp blade to hand.

A cutting mat is useful for protecting the working surface when cutting masks. Purpose-made cutting mats will even heal their own cuts, so they last a long time.

Some also have a grid pattern marked on them, so that you can check if the line you are cutting is straight or parallel to the edge of the board.

You will also require a good stock of sharp pencils of varying grades from hard to soft, as well as sketch pads and pads of tracing or transfer paper. Coloured pencils and felt-tipped pens are useful for preparing roughs, and water-soluble crayons can be used on the finished artwork to enhance the colour that the airbrush has laid down. A technical drawing pen is invaluable for drawing lines of a constant width. Soft, kneadable erasers are useful for removing unwanted pencil lines, and hard-tipped ones for rubbing back colour to create highlights.

Most artists keep a selection of small sable brushes for painting fine details on the artwork and bristle brushes

There are various instruments and accessories which you will probably use when you are creating the original drawings for your airbrushed artworks. A set of French curves contains an infinite number of different arcs, and dividers are invaluable for checking dimensions accurately. A selection of pencils of different grades will always come in handy.

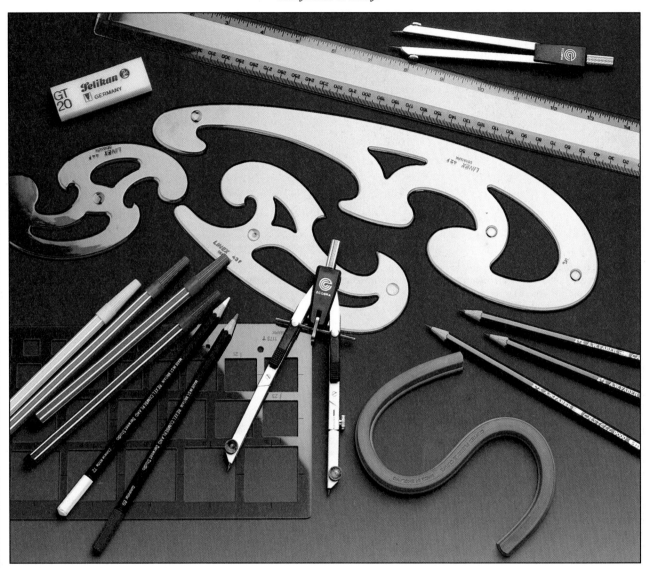

for mixing paint and transferring it to the airbrush. You will also need palettes with mixing wells – the traditional ceramic ones are easier to clean than the plastic ones.

Finally, keep a plentiful supply of adhesive tape, rolls of paper towels for cleaning up spills, solvents for cleaning out the airbrush, lighter fluid for removing greasy marks from your artboard – and a large waste paper basket for all those offcuts and unwanted sketches.

———————— DRAWING INSTRUMENTS ————————
Much of the success of a finished artwork depends on the accuracy of the final drawing. Although parts of your picture may be created freehand, specialist drawing equipment will help you produce more accurate and professional-looking results.

A good ruler is a first essential. Transparent plastic ones marked with a series of parallel lines help you to check the accuracy of straight lines in your drawing. You will also need a metal ruler to use as a guide when cutting straight-edged masks – plastic rulers soon become ragged when used for this purpose.

A pair of dividers is invaluable for checking the exact dimensions of a reference drawing or a solid object, and for transferring these dimensions to the drawing. A set of compasses will also earn their keep in the studio – it is surprising how many images contain arcs and circles.

Drawing accurate curves is an essential part of airbrush work, and there are various ingenious devices that will help you here. One of the most useful is a set of French curves. These are clear plastic templates of

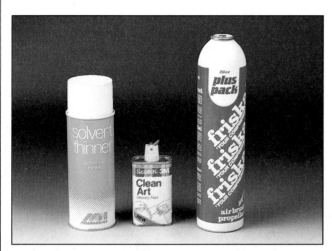

There are a number of products on the market, such as cleaning fluids and solvents, which are designed to make life easy for the airbrush artist. It is always worth keeping an aerosol of compressed gas in your drawer in case your compressor decides to stop working at a crucial time, or if you need to use the airbrush away from the studio.

The most basic type of airbrush consists of a felt-tipped marker pen connected to an airline. This sort of equipment does not let you make up your own colours and you will not have the control over the spray that a good airbrush offers, but the colours can be changed very quickly and some artists find it ideal for quick freehand sketches.

varying sizes, which are designed to give as many degrees of curve as possible. They can either be used as masks, or as a guide when cutting masks.

For more irregular curves, a flexible curve is ideal. This is a strip of flexible material that will hold any shape into which it has been formed.

If you are using three-dimensional reference, a profile guide will help you to reproduce its shape accurately on paper. These guides consist of rows of fine teeth set in a holder. You hold the guide at right-angles to the shape and gently press against it to make the teeth slide back, leaving an accurate outline of the shape. You can then draw around the form on a piece of paper to make a mask.

AIR CANS

If you are a newcomer to airbrushing, you will find compressed air cans a relatively cheap way to get the feel of the airbrush before deciding to invest in an expensive compressor. These aerosol-type containers are not suited to regular use, however, as they are uneconomical in the long term. Another drawback is that there is a gradual weakening of pressure as they empty. Because they contain only a small amount of air, there is a risk that they will run out at a crucial moment, but they are useful for emergencies, or for jobs that involve working away from home.

Larger cylinders of carbon dioxide can be bought or hired. They are longer-lasting and more controllable than air cans, and are usually fitted with an air pressure regulator and a moisture trap.

AIRBRUSH ACCESSORIES

Some other optional items of equipment which regular users of the airbrush will find useful include the following.

AIRBRUSH NEEDLES

Airbrush needles are very delicate, and a damaged one must be replaced straight away. It is a good idea to have spare needles available at all times.

COLOUR CUPS

It is advisable to have a readily available colour cup filled with water or solvent to flush through the airbrush quickly should you need to leave your work for a short time. This precaution will prevent colour drying up on the needle and inside the airbrush.

AIRBRUSH HOLDERS

An airbrush holder clamped to the edge of your desk will keep your airbrush horizontal if you need to put it down while there is still colour in the cup.

CARE AND MAINTENANCE

Although airbrushes are extremely delicate and finely balanced instruments, they are relatively easy to service and maintain and, if properly looked after, will give years of service. It is worth getting to know your airbrush and understanding how it works, so you can diagnose faults quickly if they occur. The needle and nozzle, for example, can produce problems, but these are usually easily tackled with a few basic tools and a little manual dexterity. However, it cannot be emphasized enough that thorough and regular cleaning is essential to the continued smooth running of your airbrush. Dust, moisture and hardened pigment can clog up the airbrush and interfere with its working capacity, so get into a routine of cleaning the airbrush at the end of a day's work, at each colour change, or if the airbrush is left standing for even a short time while working. This applies particularly to fast-drying mediums such as acrylic paint or Indian ink, and to masking fluids and fixatives.

FLUSHING THROUGH

When you have finished spraying, any paint left in the colour reservoir can be poured back into a container to be used again. Wipe away any drops of paint remaining in the reservoir using a paint brush or a lint-free rag, then point the airbrush at a sheet of scrap paper and pump air through it until the spray becomes colourless. Alternatively, close a plastic bag around the nozzle as you spray – this will prevent stray paint droplets landing on the work area. There will still be tiny amounts of colour left inside the airbrush, so fill the reservoir with clean water, or the required solvent if non-water-based colour was used, and flush this through until it runs clear.

CLEANING THE NEEDLE

The tapered point of the needle must be in good condition as it controls the amount of paint that the airbrush sprays. From time to time the needle should be withdrawn from the body of the airbrush to give it a more thorough cleaning and to check for signs of wear and tear. This is a delicate operation as it is easy to damage the tip of the needle as it slides out of the airbrush. First, unscrew the airbrush handle to reveal the blunt end of the needle, which is anchored in place by a locking nut. The locking nut should be just finger-tight, so that it can easily be unscrewed to allow the needle to slide out of the airbrush. You should now be able to pull out the needle without difficulty. Hold the airbrush body so that you can guide the needle out with your fingers as you pull it with your other hand – this will help to support the needle and will prevent the delicate tip from snagging on the body.

Examine the needle tip under a magnifying glass. If it is badly worn or damaged, it must be replaced, but a slightly bent tip can be straightened by rolling it gently against a smooth, hard surface such as a piece of glass or metal (make sure it is scrupulously clean). Hold the needle so that the pointed tip lies flat on the surface. Now

Left: *This diagram shows the essential components of an independent double-action airbrush. When the lever is pressed down, the air valve opens and allows more air to flow up the airline and through the airbrush. When the lever is pulled back, the tip of the needle slides back and uncovers the hole in the nozzle, allowing a greater volume of paint to flow.*

Right, top row, left to right:
Aircap; Nozzle washer, nozzle and aircap; Locking nut assembly.
Middle row, left to right:
Airline connector; Aerosol control valve; Airline connector.
Bottom row, left to right.
Spring box assembly; Airline connector; Airline adapter

The needle is the heart of the airbrush. Its delicate, tapered point needs to be in perfect condition if it is going to do its job properly and control the flow of paint through the nozzle. A needle with a blunt or damaged point will cause an uneven or uncontrollable spray pattern. New needles are quite cheap, so it is always worth keeping a supply of spares.

anchor the tip with your fingernail, rotate the needle slowly and draw it away so that the tip passes under your nail.

Any stains or traces of paint on the needle can be removed by gently pulling the needle across the palm of your hand, or a tissue soaked in cleaning solution, rotating it as you do so.

CLEANING THE NOZZLE

The nozzle, through which the paint is actually sprayed, can very easily become clogged up with dried paint, so regular cleaning is necessary to keep the airbrush on top form. The design of the nozzle assembly varies from one make of airbrush to another, but the dismantling procedure is broadly similar for most models. The nozzle is usually protected by an air cap, which is unscrewed first. If it is very tight, loosen it carefully with a pair of pliers. Some nozzles are of the 'snap-on, snap-off' variety; the screw-in types come with a special spanner for unscrewing the nozzle. DeVilbiss airbrushes also have a nozzle washer which fits behind the nozzle. This small washer may come away with the nozzle or may need to be teased out with fine pliers. Check that the washer is undamaged before you replace it.

Soak the air cap and nozzle in water or cleaning solution. Any stubborn deposits remaining can be cleaned away using metal polish and a paper tissue. Twist a corner of the tissue into a point and dip it into the metal polish. Rotate the tissue and work it fully into the nozzle or air cap to rub away the accumulations of paint that have built up. When all of the paint has gone, give the nozzle a final polish with a twist of clean tissue.

To reassemble the airbrush, carefully guide the needle backwards down the airbrush, placing your fingers against the rear of the airbrush and running the needle through your fingers so that it is fully supported as it slides back into the body. It helps if the needle is very slightly lubricated so that it can slide easily inside the airbrush (normally, handling the needle while you clean it will transfer a little grease from your hands, giving the needle all the lubrication it needs). Make sure the lever control button is forward and down or the lever may obstruct the needle as it slides. Pull the needle from the rear until the tip is behind the nozzle aperture. Replace the air cap and nozzle, then slide the needle forward until it sits comfortably in the nozzle. Finally, tighten the locking nut, screwing only finger-tight, and replace the handle.

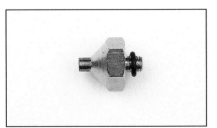
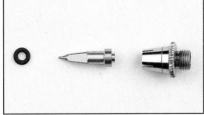
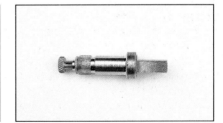

BASIC CONTROL

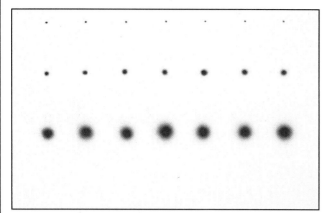

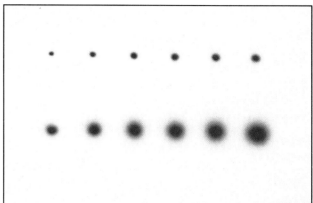

You can practise fine control of the airbrush by spraying dots of different sizes. The small dots were sprayed with the airbrush very close to the paper. Then the airbrush was gradually pulled back to spray each line of larger dots. Try to keep the lines as straight as possible and make the dots in each line about the same size.

In this exercise, the dot was sprayed first and then the circle was airbrushed around it. It may take a while before you can spray dots and circles as small as these! When you have mastered this technique, you will be able to aim the spray of the airbrush very accurately, which will be invaluable for doing freehand work.

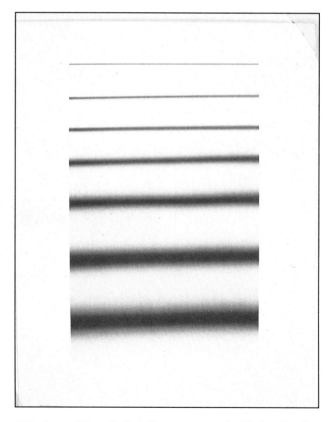

Like the small dots, the finest lines were sprayed with the airbrush held at very close range. The distance between the airbrush and the paper was then steadily increased. Ideally, the colour of each line should be completely even. The lines have crisp ends because the sides of the paper were masked and the masking was then removed.

First mask a piece of paper with masking film, then cut a rectangular window in the middle of the film and peel the window off. Then, spray a line across the paper, either freehand or using a ruler for guidance. Keep the airbrush spraying all the way across the paper and onto the masking film at each side.

The idea is now to make the top half look rounded, like a pipe, and the bottom half look like a flat wedge. It may help to cover the lower part with a spare piece of paper so that no unwanted colour falls on it. Spray complete horizontal lines, starting with the darkest areas, gradually pulling the airbrush back for the lighter areas.

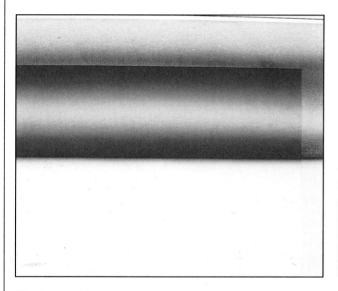

The pipe acquires its rounded, three-dimensional shape because the intensity of colour gradually falls off between the raised central part (nearest to the eye) and the edges (furthest from the eye). The even gradation of colour suggests that the pipe has a smoothly curved shape which reflects light from its top surface.

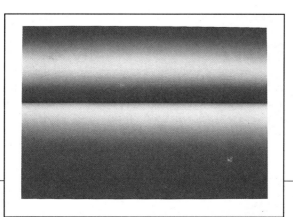

When the pipe and the wedge start to take shape, you can make any adjustments by carefully reinforcing any sections that need to be made darker. Again, always spray horizontally, or you will probably be left with blobs which will be very difficult to disguise. When the paint is completely dry, peel off the masking film.

MASKING

Masking is the process of isolating certain areas of an image being worked on by covering them with a paint-resistant surface, so that no paint or ink falls on that area while another part of the image is being sprayed. Any shape which is to have a precise, or even soft, edge requires a mask.

Masking is the key to successful airbrushing. There are a few airbrush artists who spray freehand, but almost all airbrushed artworks involve some degree of masking. Good masking techniques, although they take time to acquire, are essential to the airbrush artist – without them, any artwork is likely to look sloppy.

When working with masks, you should generally be careful to spray at right-angles to the surface, otherwise there might be a build-up of paint or ink at the edges of the mask if it touches the surface of the artboard.

Anything that is intended to prevent paint from reaching the support can be used as a mask. Masking materials can be divided into two broad categories, known as 'hard' and 'loose' masking, and many of the images you produce will incorporate both. Hard masks are physically attached to the support and give a clean, crisp edge; loose masks are held against the support, or just above it, and give a softer, less regular edge.

MASKING FILM

Self-adhesive masking film is the most popular masking method used by airbrush artists. Masking film gives a 'hard mask' look, with clean, crisp outlines. This is because the film is physically attached to the surface, so no medium can creep under the edges. It is also very thin, preventing a build-up of paint at the edges. Because the film is transparent it allows those areas covered to remain visible, which is a great advantage when judging colour and tonal values against those areas already sprayed.

Masking film is supplied in flat sheets or on a roll, its adhesive side protected by a peel-off backing paper. The adhesive is low tack, so although the film sticks firmly to the surface, it does not lift or damage it when peeled away after use. The film is available in either a matt or a gloss finish. The matt finish is relatively new, but is rapidly gaining favour because it is possible to draw directly onto its surface before cutting out the required shapes.

The film is laid over the artwork, peeled from its backing paper and smoothed down into place. The area to be sprayed is then cut out and lifted away, exposing the surface below, onto which you spray. When you have finished work on one area, and it is completely dry, it can be covered up and a new area exposed for spraying. Masking film can be applied over areas that have already been sprayed, so long as they are completely dry.

Masking film is expensive, and it would be wasteful to use it to cover large areas of the artwork. To avoid wastage, use layout paper or cartridge paper to protect the artwork from residual spray, and apply film only to the section being worked on. Cut a hole in the paper larger than the detail area, so that the masking film can be adhered to the surface.

Cutting masking film without marring the surface beneath takes practice. Always use a small surgical scalpel with a sharp, new blade, as old ones quickly lose their edge and don't cut cleanly. The scalpel must cut only through the masking film: use the weight of the blade itself, not pressure from the hand, to avoid scoring the artwork. Use a steel rule for guiding the scalpel along straight lines: plastic and wooden rulers might be nicked at the edges by a scalpel, resulting in a ragged line.

Once you have cut a mask, it is possible to reuse it if you handle it gently, but it is a good idea to keep a clean piece of backing paper to hold the masks you are saving, although be warned that the thin plastic film can become distorted and lose its adhesiveness. Therefore in the case of highly detailed areas, a fresh mask is always advisable.

To remove masking film when a section is completed, place your scalpel so that the blade is flat on the surface of the support. Very lightly pick at the edge of the film until it comes away from the support, then carefully peel off the rest of the film.

LIQUID MASKING

Liquid mask is a rubber solution that is painted onto the surface with a brush and dries to a paint-repellent skin, which can be peeled or rubbed away when the sprayed area around it has dried. The liquid is especially useful for masking small and intricate shapes, where masking film becomes difficult to cut accurately. Masking fluid can also be used to create texture – for example by spattering it on to the surface with a toothbrush – and fine lines or dots can be cut into a patch of dried fluid.

Liquid masking does have some drawbacks, however. It can leave a yellowed discolouration when it is removed, and on soft or textured papers, care is needed when removing the masking to avoid surface fibres being damaged. If possible, avoid using the liquid over a previously painted area, as it must be rubbed quite vigorously and this can spoil the paint surface. Acrylic paints may adhere to the masking and seal it to the artwork, or may be drawn off with the mask. The golden rule is to test the liquid mask on the support first.

LOOSE MASKING

A loose masking technique is one which allows the sprayed colour to creep under the mask, giving a clear but soft delineation to a sprayed edge. Loose masks can be almost anything you choose, and offer a huge range of textures and images to be explored. By varying the

distance between the mask and the support, you can vary both the tone and the sharpness of the image. The closer the mask is held to the surface, the less spray will escape underneath it, so the more distinct the image will be.

If you want a fairly distinct edge, torn paper, thin card and acetate, as well as preformed plastic templates such as French curves, are all suitable masking materials. For a softer, more amorphous image, try using paper tissue, blotting paper or splayed-out cotton wool. Creative effects can be achieved with 'found' objects such as stones and pebbles, bark, twigs, leaves and feathers. Open-weave fabrics allow the sprayed colour to pass through and between the fibres, creating interesting textures and patterns.

When you find or create a mask that is particularly successful, keep it carefully and you will soon build up a useful 'library' of masks which will save you time and effort in the future.

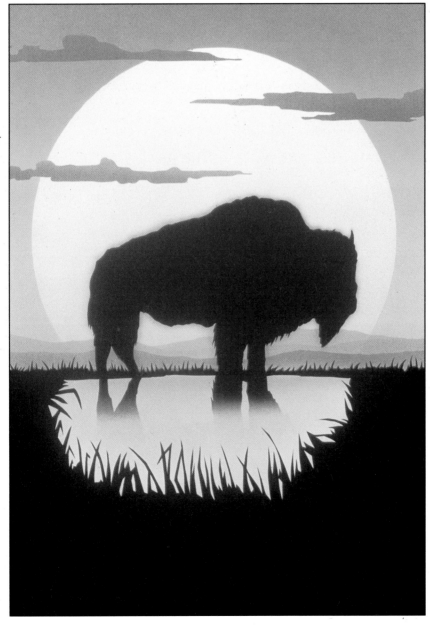

Pete Kelly masked the whole of this artwork with a sheet of masking film, then removed the mask, piece by piece, spraying the darker areas first and finishing with the light tones of the sun. He airbrushed most of the illustration in ink, and used a sable brush for the slight 'halo' effect around the body of the bison.

Found Objects

A mask need not just be a piece of transparent film. A vast range of objects can be used as masks, allowing a great variety of effects to be created. Here are a few suggestions but why not develop your own unique effects by experimenting with everyday objects.

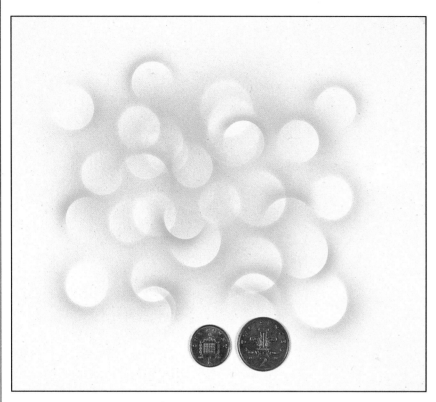

─────── 1 ───────

Coins make good masks because their weight holds them in place, automatically creating a hard edge. If you want to airbrush a soft-edged circle, you should hold the coin slightly above the surface. To airbrush an arc, just spray around part of the edge.

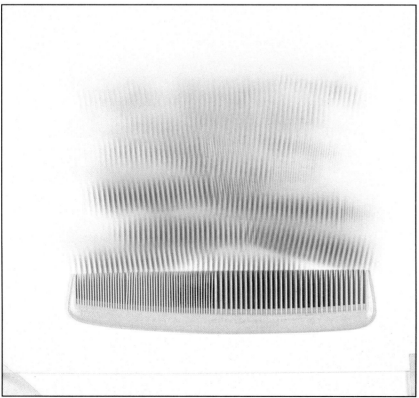

─────── 2 ───────

If you spray lightly against a comb, particularly if it is held just above the paper, it will create a blurred effect. When you spray more heavily, with the comb touching the paper, the result will be stripes.

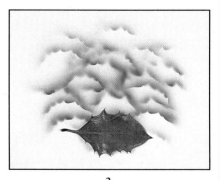

─────── 3 ───────

Leaves like this holly offer unusual possibilities, and not just for Christmas cards. Some parts of the leaf's uneven surface will touch the paper while the rest will be raised just above it. This irregularity results in a mixture of hard and soft edges.

4

You can use small objects such as pine needles singly or in any number, making up a pattern before you spray. Light masks like these may need to be anchored in place to stop them being blown away by the spray from the airbrush.

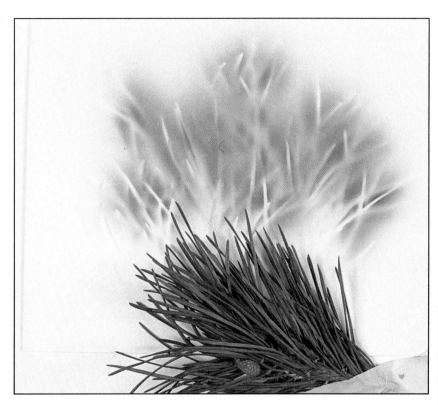

5

Nature provides all sorts of materials which can be used as masks. Straw can be arranged to give a variety of lines and angles and, like the holly leaf, gives a mixture of hard and soft edges, since only parts of the clump are in contact with the paper.

6

Paper is infinitely versatile. Thick paper cut into a sharply defined shape makes a mask that gives a distinct, hard edge. At the other end of the scale, torn, light paper (such as newsprint) held just above the surface, will give a soft, fluffy edge.

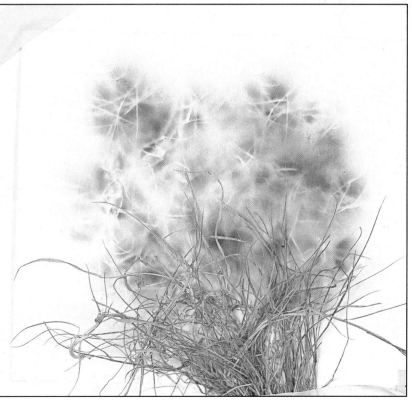

Hard Masking

The masking technique used for this artwork is known as hard masking. It relies on adhesive masking film which gives sharp clearly defined edges. The transparent water colour enables the shades of the flower to be built up gradually, with each successive wash of colour intensifying the colours underneath.

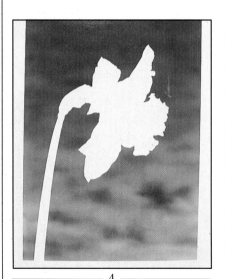

— 1 —

The preliminary sketch shows all the detail of the daffodil that will appear on the final artwork. The details of the background are not included because they will be airbrushed freehand. When the sketch is finished, trace the details onto the board.

— 2 —

This is the last chance you will get to make sure all the details of the sketch are correct. Having done this, remove any greasy marks from the board by wiping it over with a cloth soaked in lighter fluid. Now carefully spread a sheet of masking film over the entire artwork.

— 3 —

Next, cut out the shape of the daffodil and remove the masking film that covers the background. Airbrush the background freehand with green watercolour to give it a blurred 'out of focus' effect.

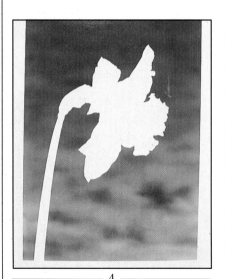

— 4 —

When the background is completed, remove the masking from the daffodil, its stem and the border around the artwork. Then remask the entire artwork with a new piece of film. Cut out all the lines of the individual masks for the daffodil, following the lines that were traced onto the board.

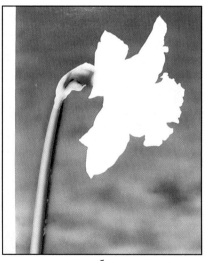

— 5 —

Remove the film from the stem of the daffodil and build up the watercolour gradually, with freehand spraying, so that it is most intense along the edges of the stem. This leaves a lighter shade on the centre line of the stem, making a highlight which gives the impression of roundness.

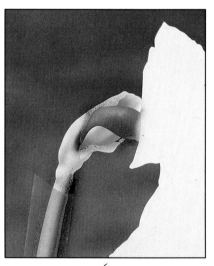

— 6 —

Now work on the main length of the stem is complete and can be covered with a piece of masking film. Cover the upper part of the stem with its original mask. Next, take the masking from the darkest area of the sepals. The first wash of light brown is quite gentle – further washes will intensify the colour.

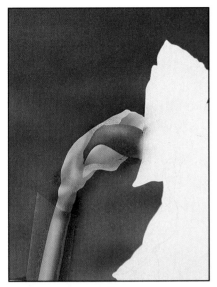

7

Expose each section of the sepals in turn so that the intensity of the colour on the darkest parts builds up gradually. The fine details of the shading within the individual sections have been achieved by careful freehand spraying.

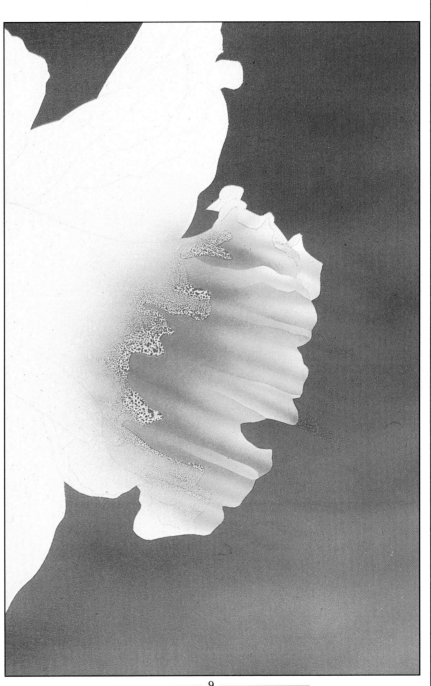

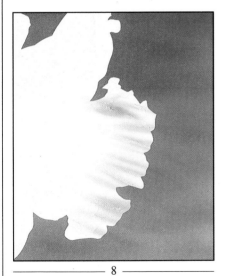

8

Now begin airbrushing the trumpet of the daffodil. As usual, start by exposing the areas which will appear darkest in the finished artwork. Spray these with dark yellow ochre watercolour. Then spray a wash of daffodil yellow – the lighter shade – onto the same area.

9

Now expose the next lightest areas of the trumpet and spray them with the same two colours. Do not remask the areas exposed for the previous stage. The airbrush follows the lines of the masks, working from the centre of the trumpet to the outside edge. This makes the stripes of colour which give a realistic 'crinkly' look.

Hard Masking

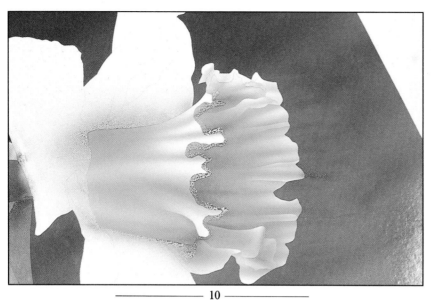

— 10 —

The trumpet is now almost completed. The shades blend smoothly from the darkest, mid-brown parts to the lightest areas, which are almost pure white. Next, expose the whole trumpet, apart from the rim. Work freehand, carefully, to make any necessary adjustments to the colours.

— 12 —

Now remask the trumpet so that it will not be spoiled by any overspray. To airbrush the petals, use a technique similar to that used for spraying the trumpet, starting by exposing the darkest parts and developing the colour with yellow ochre first, followed by daffodil yellow.

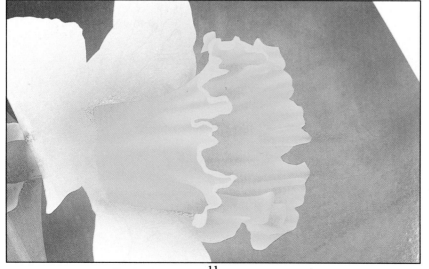

— 11 —

Peel off the final mask, covering the rim, and spray a yellow glaze over the whole of the trumpet. This will brighten it up and, because it emphasises the contrast between the light outside edge of the trumpet and the dark inside part, will give it a three-dimensional look.

— 13 —

Develop the colours of the petals one area at a time. As with the trumpet, do not remask the areas that have already been sprayed. The colours on these areas will receive a slight overspray which softens their edges and makes them look more natural.

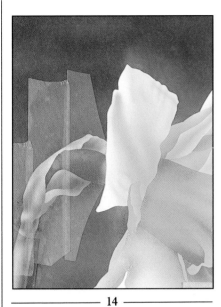

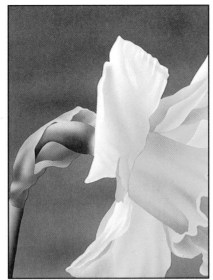

The artwork is now nearly finished. All the masking film has been removed so that any small details can be improved. This could include, as here, tidying up the edges of individual petals with a fine sable brush and using a scalpel to scratch back the small, white highlights on the petals.

———— 14 ————

Use just one mask to cover most of this large petal and develop the colours on its surface using careful, freehand airbrushing to give smoothly graded, natural-looking tones of dark yellow ochre and daffodil yellow.

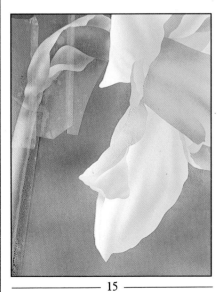

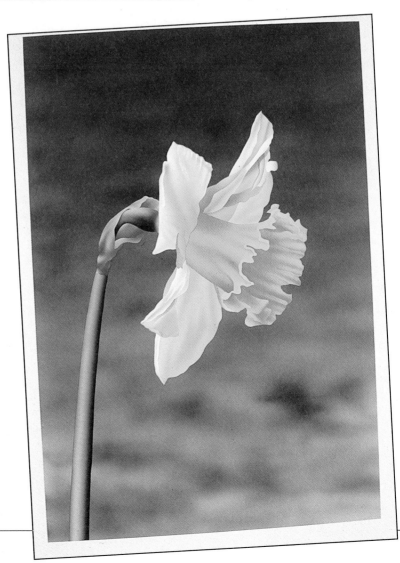

———— 15 ————

Now only one light area of the petals remains to be sprayed. Notice how the range of shades in the petals reflects the variety of darker tones in the trumpet as well as containing a whole range of lighter colours. The parts of the petals in shadow should be almost as dark as the inside of the trumpet.

Loose Masking

This illustration involves the use of loose masking.
This technique is used to create the soft edges in the artwork. The different
shades of opaque gouache enable the colours of the flesh to be built up in
stages.

— 1 —

The preliminary drawing shows all the details that will appear in the finished artwork. Hands are notoriously difficult to draw, so it is worth taking trouble over this. The final artwork can only be as good as the drawing on which it is based.

— 2 —

Transfer the drawing to the board, cover the hand with masking film and cut the lines for the main shapes. Here, the mask is shown peeled back from the thumb and hinged out of the way with a piece of tape. The first colour, a light skin tone, is then sprayed onto the darker part of the thumb.

— 3 —

Next, airbrush a darker opaque skin tone onto the thumb. This helps give the skin the realistic variety of shades a hand has in real life. The darker colour does not cover the whole area that has been painted. The lighter shade still shows around the edges.

— 4 —

The mask for the thumb can now be swung back into place. Leave the tape in position because the mask will have to be swung out of the way again later. Next, use the same process to spray the index finger.

— 5 —

If a mask is hinged in this way, it can easily be repositioned in exactly the right place. If it is repositioned even slightly out of place, you will end up with an unwanted line.

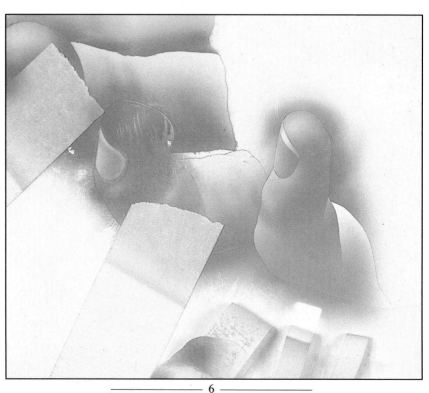

— 6 —

Use three masks for the main part of the little finger and two for the nail. Remove the masks one at a time so the colours and lines of the finger can be built up gradually. The last mask to be removed is the one covering the fleshy part of the finger.

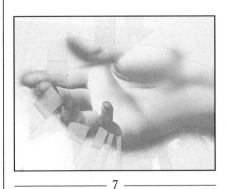

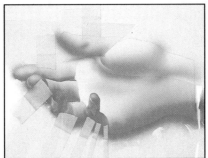

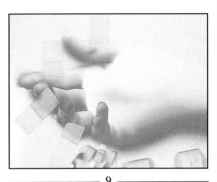

—— 7 ——
Now the masking film covering the palm of the hand has been removed. Here, the mask for the little finger has not yet been repositioned as the paint is still drying but, if you spray carefully, you can begin to build up the palm of the hand. The colours along the lower edge of the palm can be sprayed freehand.

—— 8 ——
The lines dividing the areas of colours in the palm of the hand are not as sharp as those between the fingers. Use loose acetate masks to give these softer lines. These masks can be made using the original drawing as a guide. Hold the masks slightly above the surface as the colour is sprayed.

—— 9 ——
Continue to build up the contours of the palm. Use loose acetate masks held slightly away from the surface to create the soft lines of the crease just below the ball of the thumb and the line across the palm of the hand.

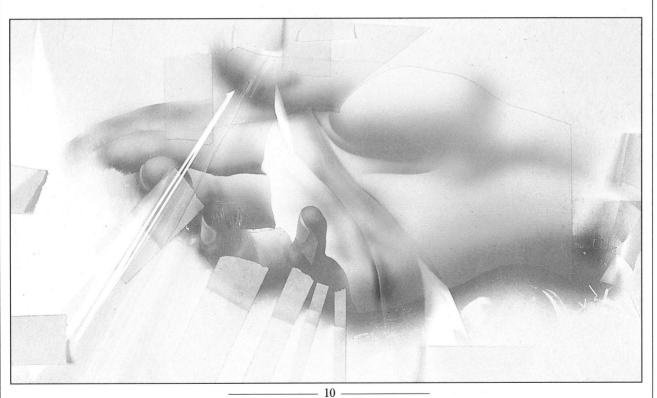

—— 10 ——
The hand can be made to look more real by using darker tone to emphasise shadows and darker areas of skin. Continue to use loose acetate masks to develop the darker colour. Airbrush this sparingly so that it looks like natural shadows rather than unrealistic black lines.

Loose Masking

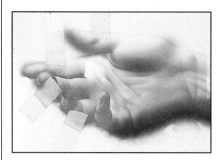

— 11 —

Use the darker flesh colour to emphasise the shadowy area at the bottom of the artwork. This is one of the darkest areas and needs to be developed carefully, freehand, so that the dark tone blends in smoothly with the lighter colours on the palm. This smooth gradation makes the hand look rounded.

— 12 —

Now remask the palm of the hand so the darker tones can be added to the fingers and thumb. Here, the masking film has been fastened out of the way with a piece of tape. Use a loose acetate mask to add the small but important detail of the crease near the ball of the thumb.

— 13 —

Develop each finger in turn, with the darker flesh shade. Here, the darker tone has been airbrushed onto the index finger, which has been remasked. Now the middle finger is exposed and the same process is carried out. The details of the creases across the joints of the fingers are made using loose masks.

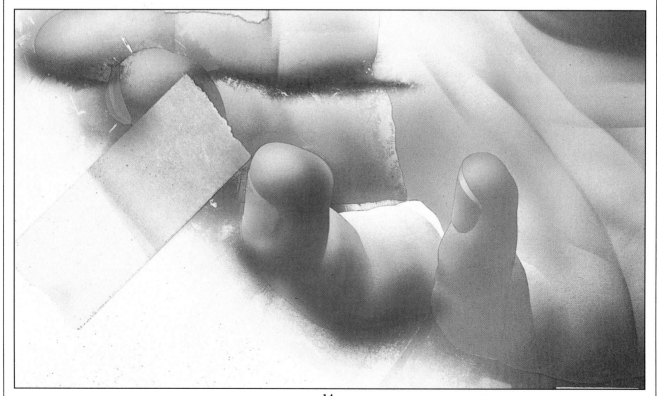

— 14 —

The darker area of colour under the fingers should be as intense as the dark shade under the lower part of the palm. Build up the colour gradually until it matches well. Notice how the shading of dark tone on the fourth finger makes slight stripes rather than a flat wash of plain colour.

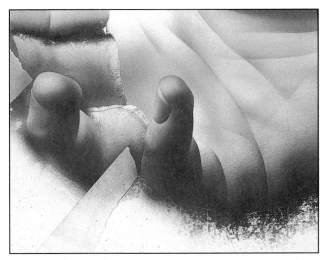

───── 15 ─────

Airbrush the last areas of darker tone onto the little finger and spray on the shadow around the edge of the finger nail. Make a final check to ensure that all the colours of the hand look realistic and that all the details, such as the finger nails and the creases in the skin have been finished off accurately.

───── 16 ─────

Remove the masking film from the fingers and make highlights on the fingertips with an eraser. Rub carefully, starting in the middle of the highlight and working outwards, until you have almost rubbed away the colour and the highlight merges smoothly into the tones of the skin.

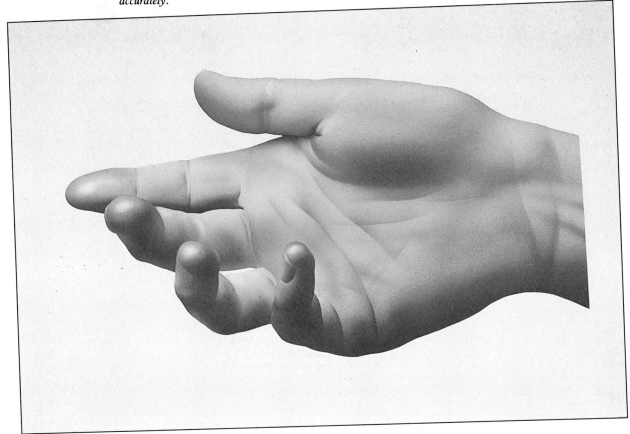

The Professionals

David Holmes used masking film for the windows to give the hard edges he required. No two windows are identical, and so a new mask was cut for each one. For the softer areas, such as the shadows under the eaves and on the windows, he used acetate film masks. The shadows on the wall in front of the house were sprayed freehand.

The whole of this illustration is airbrushed – David Holmes did not brush paint any of it. The bars of the conservatory were drawn with the aid of French curves and then cut freehand. Note how hard and soft masks have been used to give contrast between the foliage in the door and the leaves that can be seen in the blue areas.

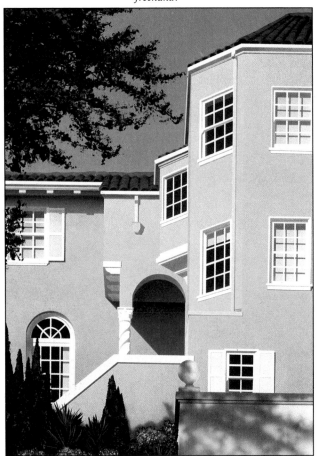

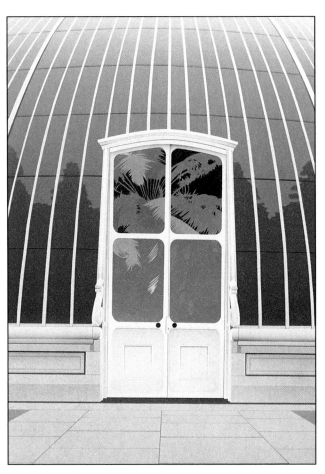

This illustration was masked in two stages. Pete Kelly first masked the toucan and all of the details of the branch, then airbrushed in ink, starting with the darker shades. He used a separate mask for the hills in the background. The white highlight in the bird's eye was touched in with a fine sable brush.

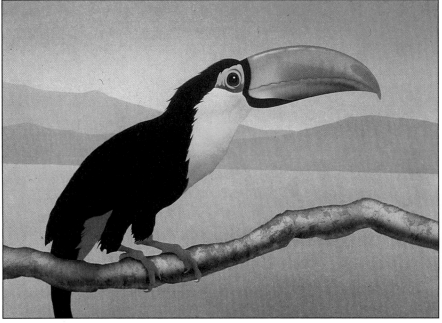

Godfrey Dowson used masking film for most of this artwork, which was airbrushed in ink. Before he laid the film down, he cut the circular holes for the pearls with a paper punch and used a compass cutter for the bigger circles. A paper mask provided the fluted edges of the frill collar. The eyes and the mouth were painted with a sable brush.

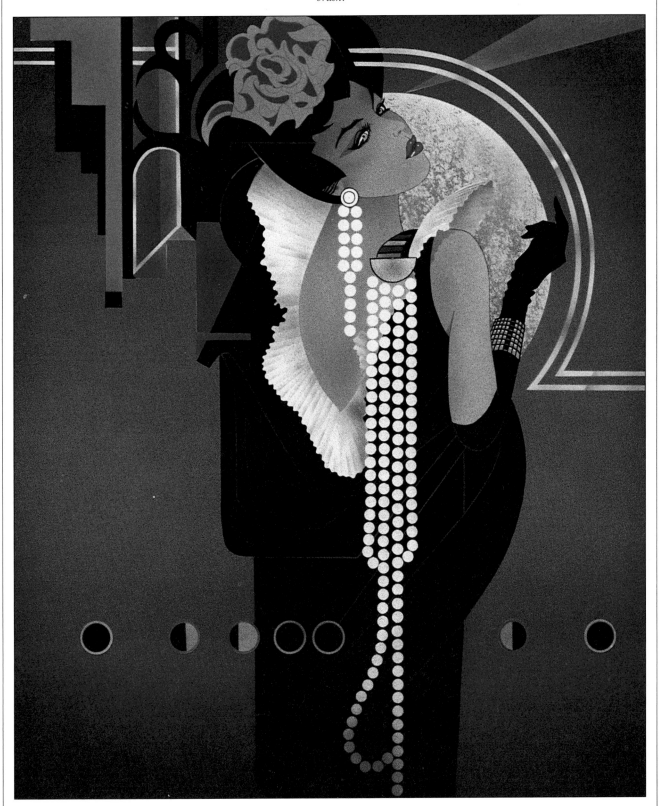

The Professionals

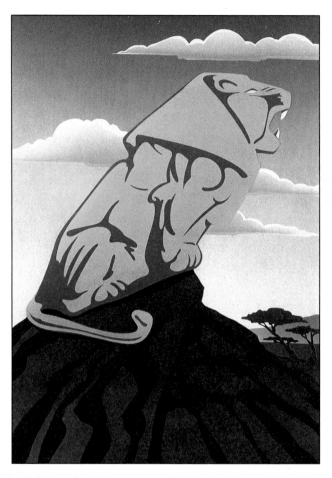

This artwork, which was sprayed in ink, shows how masking film and loose masks can be used to create a combination of hard and soft edges. Pete Kelly used masking film for the shapes in the lion, and loose masks for the grey shapes in the clouds. The soft edges in the clouds seem to make the lion look even more solid and powerful.

David Bull masked the tiger's whiskers by drawing lines of masking fluid with a ruling pen. Most of the rest of the face was masked with a stencil made of thin card – the white areas are unpainted, allowing the board to show through. Small details, such as the eyes, were masked with masking film and airbrushed separately.

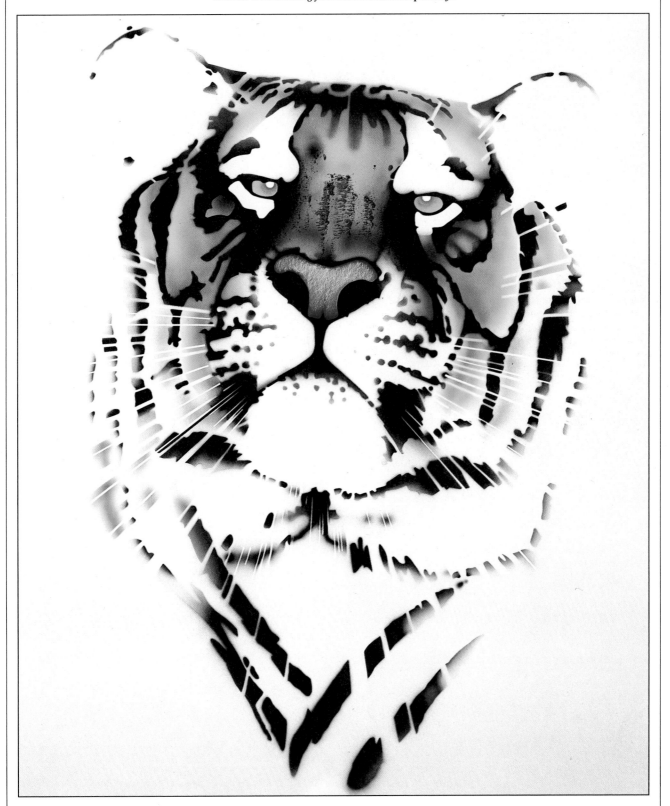

WHEN NOT TO AIRBRUSH

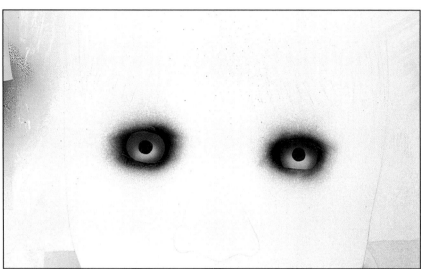

—— 1 ——

The tonal sketch shows all the areas of light and shade which were to be reproduced in the final artwork. The main lines along which the masks were cut were transferred to the board, but not the details of the shading, as these would show through the watercolours being used.

—— 3 ——

The darkest parts of the eyes – the pupils – were sprayed next. The masking was then removed from the irises and a gentle wash of colour airbrushed over these and the pupils. The wash of colour on the irises was made slightly irregular, to give the eyes a more natural look.

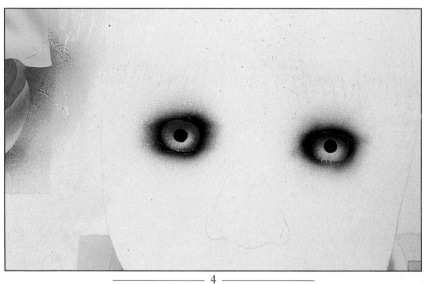

—— 2 ——

The yellow ochre and sepia tones which were to be the collar and ribbons were airbrushed first. The lightest areas of the ribbons were left almost pure white, giving the artwork its light touch. Notice how the yellow watercolour shows through the sepia which has been sprayed over it.

—— 4 ——

It was now time to give the airbrush a rest while the colour from the irises was gently scraped away, using a scalpel. This created fine lines which made the eyes look more three-dimensional. When scraping in this way, you should keep blowing or brushing the fine scrapings from the board, so that you can see what you have done.

Some professional airbrush artists take pride in creating every part of the illustration with the airbrush. Most artists, however, combine the use of the airbrush with other techniques. Very often, a coloured pencil, sable brush or even an eraser can add the finishing touches to the artwork and save a lot of time into the bargain.

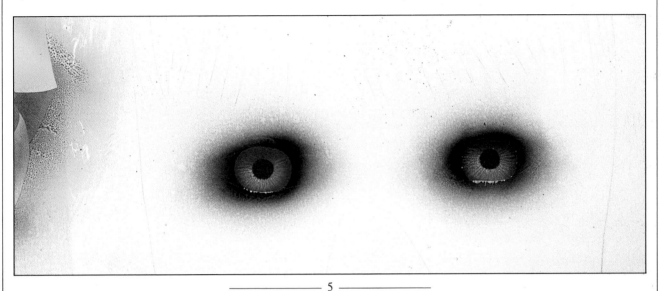

5
The lines in the irises were further developed with the scalpel. Notice how the radial lines direct attention towards the pupils, making the eyes the central feature of the face. The pupils and irises were then airbrushed with a fine wash of brown watercolour.

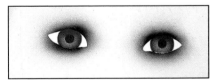

6
We then removed the mask from the whites of the eyes and softened the edges of the pupils and irises. This was done with a fine sable brush, dipped in unused paint from the airbrush's colour cup. Colour was drawn around the edges and inwards, towards the centre of the coloured area.

7
Next, the whites of the eyes were sprayed with a mixture of blue and grey and the masking removed from the centre of the eyes. The highlights were scratched out with a scalpel, starting in the middle and working outwards until the result was satisfactory.

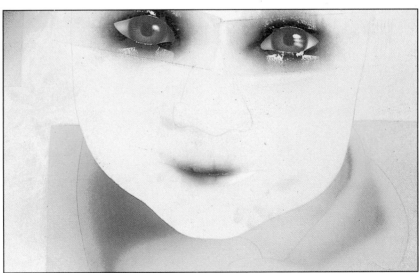

8
The eyes were remasked to protect them and the darkest parts of the mouth airbrushed. The two lips were masked separately, to make it easier to get the right range of shades within each one and to create the darker line where the two lips meet.

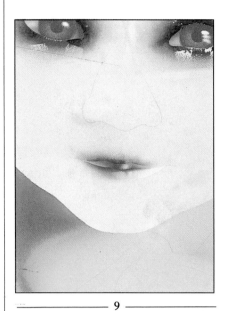

— 9 —

The next job was to pick out the highlights on the lips. These have a texture unlike that of the skin anywhere else on the body. Although they are often moist and shiny, they have a rather rough surface and can seem to be made up of a large number of small vertical segments.

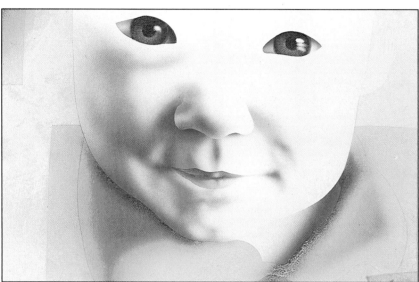

— 11 —

Work on the skin tones continued, giving the face a three-dimensional shape. If you work in this way, you must keep referring to the original tonal sketch, to see which areas need to be most heavily shaded. Notice how the dark shadow under the nose makes it stand out from the rest of the face.

— 10 —

The mouth was remasked and work began on developing the skin tones. The flesh colour was built up by airbrushing it first with sepia and then spraying on a glaze mixed from yellow ochre and red, which added warmth. The colours were airbrushed freehand within each area of masking.

— 12 —

Although it was possible to do so, there was no point in cutting masks fine enough to allow the eyelashes to be airbrushed. The eyelashes were added with a pencil. Notice how the eyelashes frame the eyes, emphasising the contrast between their colour and that of the skin.

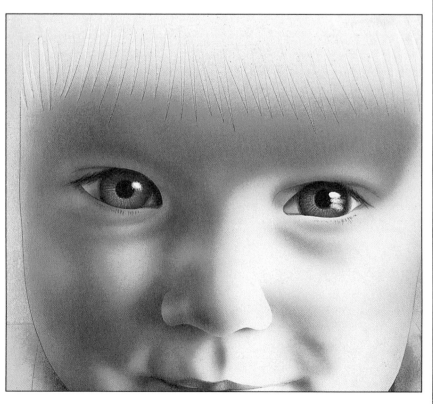

————— 13 —————

The edges of the lips were also reinforced with a coloured pencil. The line was drawn firmly on the darker side of the mouth, fading to nothing on the lighter side. Notice how the lightest parts of the lower lip have virtually no colour at all – our imagination fills in the shape for us.

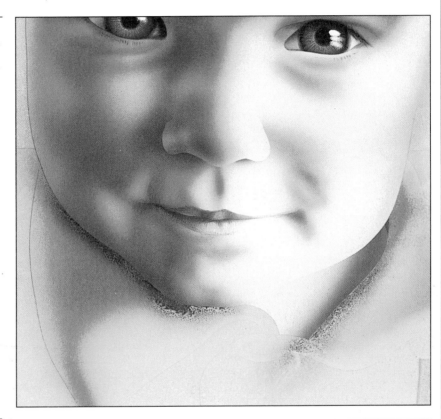

————— 14 —————

Once the masking covering the forehead was peeled off, the outline and details of the hair could be developed. The point of a scalpel was ideal for this because it is sharp enough to make very fine, distinct lines which look like fine strands of hair. The number of lines was increased until the fringe looked realistic.

――――― 15 ―――――
The lighter tones in the hair were created with a sable brush, using a mixture of yellow, yellow ochre and sepia watercolours. It would be difficult to achieve the effects of strands of hair with an airbrush without cutting a lot of intricate masks – but with a sable brush, it is no problem.

――――― 16 ―――――
The darker shades of the hair were also added with a sable brush, this time using a mixture of sepia and burnt umber. The darker colour gives shape to the head. Now, only the finishing touches remain, such as adding soft edges to the side of the fringe and washing over the hair with a fine spray of yellow ochre.

he Professionals

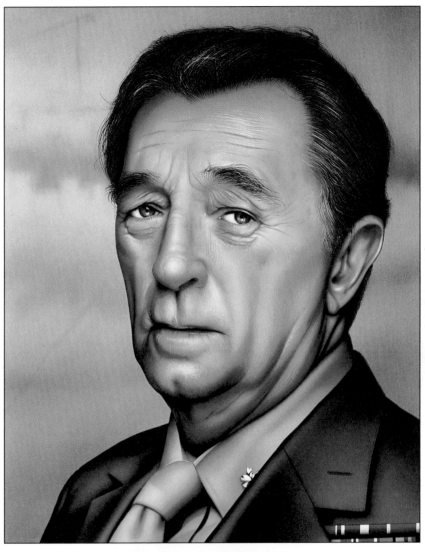

Above: *In this illustration, Nick Farmer created the basic tones with an airbrush, then used a scalpel and a hard eraser to pick out the harsher highlights. The softer highlights, like the light areas on the chin and the upper lip, were added with a soft eraser. The individual strands of grey hair were painted with a sable brush.*

Left: *Alfons Kiefer used an airbrush for the main areas of colour in this artwork, such as the flesh tones and the shirt. It would be possible to mask and spray all of the individual strands of hair, but it is much easier and quicker to pick them out with a scalpel and a sable brush. The highlights on the chin and lips were reinforced with an eraser.*

The Professionals

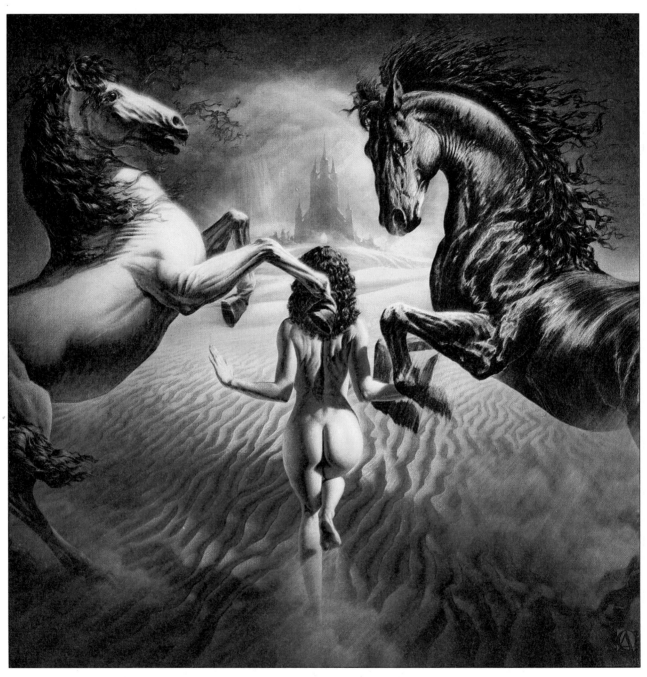

Above: *Adrian Chesterman created this artwork for his personal portfolio. He airbrushed the main areas of solid colour in the sand, the girl's flesh, and the brown horse. The multicoloured stripes of colour on the other horse were drawn with coloured pencils, and the highlights of the girl's hair and the horses' manes were added with a sable brush.*

Right: *This portrait, by Adrian Chesterman, was airbrushed onto canvas. He added the individual strands of the girl's hair with coloured pencil crayons, and then used a sable brush for the finely-detailed shadows on the shoulders. The highlights on the face, in the eyes, and on the foliage were also touched in with a fine brush.*

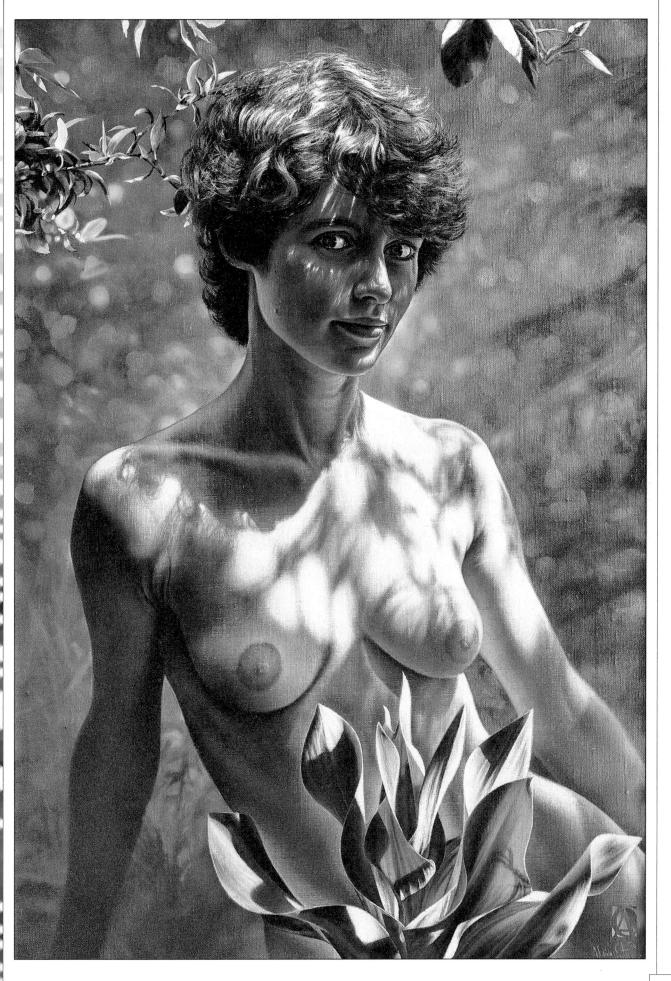

TYPES OF MEDIUM

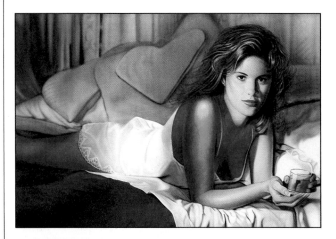

Any kind of colouring agent that is used to cover a surface is known as a medium. The airbrush can handle most kinds of medium but the ideal consistency is approximately that of milk. If the medium is too thick, it may not flow freely enough and may clog up the airbrush.

There are types of medium available specifically for use with an airbrush but if you are not sure always ask the manufacturer – a phone call is a lot cheaper than dealing with a clogged airbrush.

WATERCOLOUR

Watercolour is the classic medium for airbrush use. It is transparent, which means that each layer of paint will show through the next. This transparency gives the artist complete control over the intensity of the colour. If a colour does not look rich enough, you can simply spray it over until you have achieved the effect you want. The other advantage is that watercolour can be dissolved by water and so it is easy to clean out the airbrush after use.

Watercolour paints are available in a wide range of shades. Some bottled varieties are ready-mixed to the correct consistency for airbrush use. If you choose to buy water colour in tubes or blocks, these will need diluting before they can be sprayed. To dilute the watercolour, just mix with a small amount of water in a suitable container. Unless the domestic water in your area is particularly pure, it is always best to use distilled water. Mix the water thoroughly a little at a time, into the paint, until the correct milk-like consistency has been achieved.

GOUACHE

Gouache contains the same pigment as watercolour, with the addition of precipitated chalks which gives gouache its opaque quality. These components are then bound together with gum arabic. Therefore a wash of gouache will obscure any colours underneath. This helps when you want to add highlights to a dark subject, or create any solid areas of colour, but makes it impossible to use the watercolour technique of gradually building up to the required colour. Gouache is also soluble in water, so that a good flushing through with water should clean away any gouache in the airbrush.

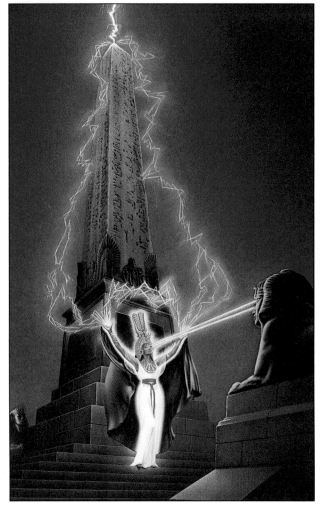

Andrew Farley used a combination of ink and water colour for the airbrushed parts of this artwork. There is no paint on the pure white areas of the dress – it is the board showing through. The white board adds brightness to the lightning, which was sprayed in watercolour.

Above left: Doug Gray used inks, sprayed freehand, to create the fabric of the cushions and the curtains. The harder, shinier look of the girl's slip was achieved with acrylic. He also used coloured pencil crayons and watercolour in other parts of the artwork. The streaks of colour in the girl's hair were added with a fine sable brush.

Some cheaper types of gouache, such as poster paints, are less suitable for airbrush use because they contain coarser particles of pigment which would make it unsuitable when you want to create completely smooth washes of colour.

ACRYLICS

Airbrush artists used to view acrylic paints with extreme caution. Their quick-drying properties, combined with the difficulty of dissolving them, led to many clogged airbrushes. There are now ready-mixed acrylics, designed specially for the airbrush with a built-in drying retardant which gives you ample time to clean the airbrush after use. Some general-purpose acrylics contain shellac, which quickly dry inside an airbrush with disastrous results, so always check first. If you are unlucky there are specially formulated cleaning fluids for airbrushes but do not attempt to use anything else.

Acrylics are available in opaque, semi-opaque and translucent colours, making them very versatile. When acrylic paint dries, it forms a durable, waterproof surface which can stand a certain amount of careless handling without showing any damage. The surface of an acrylic artwork is rather like a sheet of smooth plastic – it can be wiped down if it gets dirty.

INKS

Although ink is a transparent medium like watercolour, a wider range of effects can be achieved. Many artists favour ink because of their brilliant colours. They are ideal for subjects which demand a bright and striking appearance allowing you to lay down, and achieve, a vibrant colour with one sweep of the airbrush instead of spraying several layers.

Inks are available in bottled form, already mixed to the ideal consistency for airbrushing. As with any other medium, you should flush out the airbrush as soon as you have stopped working with inks. This is particularly important if you have been using a waterproof ink which cannot easily be dissolved once it has dried. When ink dries, it forms a hard surface which can stand a few knocks. It has a shinier appearance than watercolour with a slightly metallic look which makes it ideal for subject matter such as chrome.

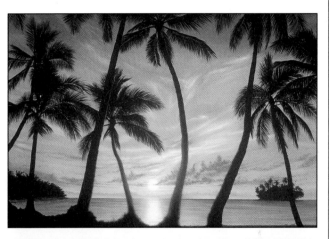

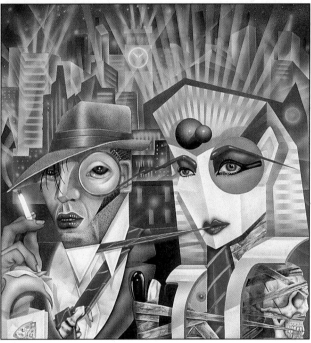

Ink is the main medium that was used for this illustration. Godfrey Dowson sprayed the background in dark grey, then a lighter shade was airbrushed over it. He used the same technique for the flesh tones in the faces. The red tones were also built up from two shades – a final coat of transparent red ink brightened up the base colour.

Top: *In this illustration, by Andrew Farley, the range of tones, silhouetted by the trees, grade smoothly from the bright yellow of the sun to the purple of the clouds. Notice how the tree trunks in the centre of the image are more brightly lit by the sun, heightening the impression of a hot, tropical evening.*

Watercolour

This artwork has been airbrushed with watercolour. Because this is transparent, you can increase the intensity of the shade by spraying further washes on top of existing ones. In this example, both the red of the wine and the grey of the glass have been developed in this way.

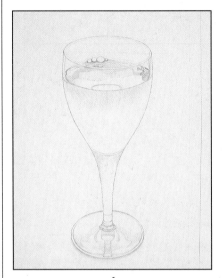

1

This detailed drawing of a glass of wine shows the areas of light and shade that will make all the difference to the final artwork. At this stage, you can still make any last-minute adjustments to the drawing – once it has been transferred to the board it will be much harder to make changes.

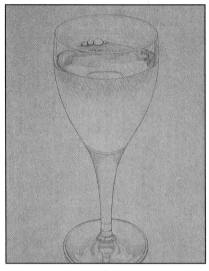

2

To transfer the drawing, tape it in position on the board over a piece of tracing down paper. Take great care when you go over the lines with a pencil, as any small slips will be faithfully reproduced on the board. Do not transfer the areas of shading as these will show through the watercolour.

3

Check that all the lines you will need for guidance are now on the board. Remember that you will still need to refer to the detailed drawing so that you can see where the shading should be.

4

Wipe the board over with some lighter fluid on a soft cloth, to remove any greasy marks which may stop the paint from adhering. Now carefully spread a sheet of adhesive masking film over the board and cut it, following the pencil lines on the board exactly.

5

Now airbrushing can begin. Remove the film from the areas that are to have the darkest red tones and build up the colour with repeated passes of the airbrush. The colour used is a mixture of crimson, scarlet, sepia and blue. The intensity of colour diminishes towards the edge of the glass.

6

A fine spray of the same colour makes it look as if light is shining through the glass. The reflections on the rim have been separately masked and are now uncovered. You will only need to spray a fine wash of colour – these areas will get darker as subsequent layers of colour are sprayed over them.

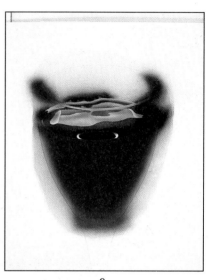

——— 7 ———

The next set of masks are removed and the different shades of red become more apparent. You can see how the areas which were uncovered in the previous picture have now become a deeper red as more colour has been sprayed.

——— 8 ———

This is the last stage of the build-up of the red part of the artwork. The reflection on the surface of the wine is now pale pink and the other reflections range from pink to medium red. The colour within the large reflection is uneven, to give the surface of the wine the impression of movement.

——— 9 ———

Remask the pink and red areas before you begin to spray the grey glass tones. It may be easier to lay new pieces of masking film here rather than try to refit the old ones. Now spray the darkest areas of the glass colour. The shade used here is a mixture of lampblack and blue watercolours.

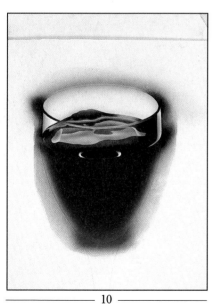

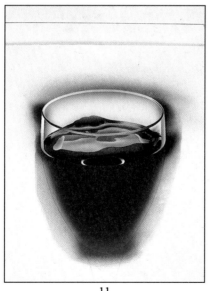

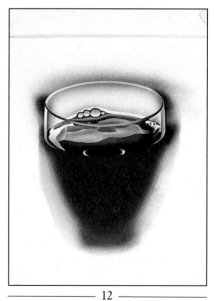

——— 10 ———

Now expose the slightly lighter grey parts of the glass. Some overspray may fall on the areas airbrushed in the previous step, but this does not matter: the extra colour will give them a slightly darker tone.

——— 11 ———

The lightest parts of the glass are, in fact, almost white and need only the most delicate spray of watercolour to make them stand out. The dark grey parts which were exposed first, together with the grey mid-tones, give the glass a realistic, curved look.

——— 12 ———

With the final masks moved from the grey parts of the glass, the all-important fine detail can be added to the top part of the artwork. The shading inside the bubbles makes them look three-dimensional and the shading on the upper surface of the glass makes it look more realistic.

Watercolour

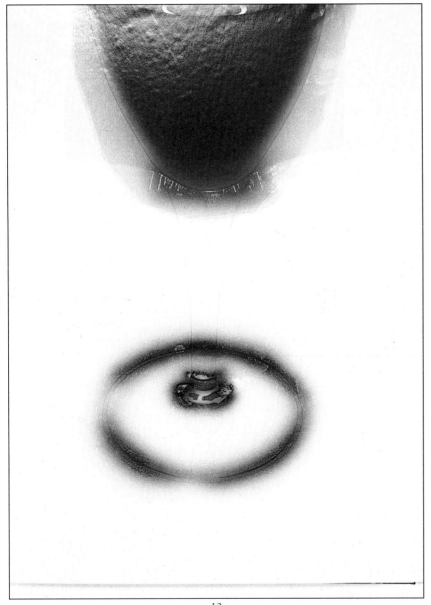

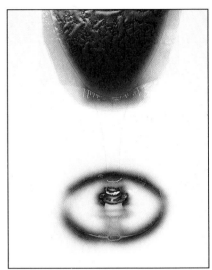

— 14 —

The final artwork gets its style from the way the light is reflected, both by the wine and the glass. The reflections in the foot of the glass are shown in a semi-realistic way. This is the first stage in developing these, and is achieved by spraying the darkest parts first.

— 13 —

The work on the lower part of the glass is done in the same way, spraying the darker parts first. The base of the bowl of the glass should be masked so that no overspray of grey falls onto the red parts of the artwork.

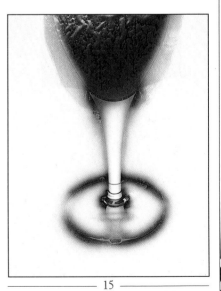

— 15 —

The rings around the lower part of the stem play a large apart in making it look three-dimensional. The shaded areas at the top of the stem also gives it the appearance of volume. Here, the first spray of grey gives colour to the darkest areas.

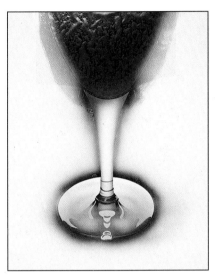

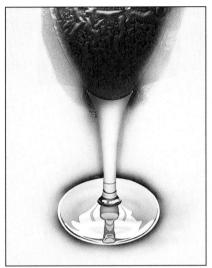

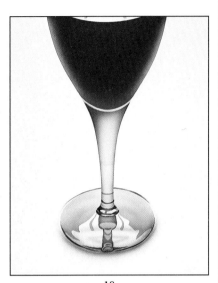

—— 16 ——

Now the mid-grey parts of the reflections in the foot of the glass are being developed, making the foot look less flat. The lighter areas of the foot have been sprayed freehand with a very delicate, graduated wash of grey – further heightening the impression that it is contoured.

—— 17 ——

The last areas of masking have been removed and the lightest reflections have been sprayed with a few gentle passes of the airbrush which show only the faintest traces of grey. The rim of the foot is almost white: it will show up on the white board when the reflections and shadows are added.

—— 18 ——

The intensity of colour in the stem of the glass is now strengthened so that it is deeper at the edges and, especially, towards the top of the stem. Next, remask the foot so that you can airbrush a small area of shadow around its front and sides.

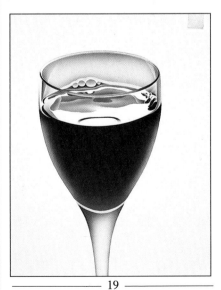

—— 19 ——

Finally, remove any remaining mask and add a few finishing touches. Here some highlights were added by scratching through the watercolour with a scalpel. The white line around the rim of the glass and the faint shading between the rim and the wine's surface were created this way.

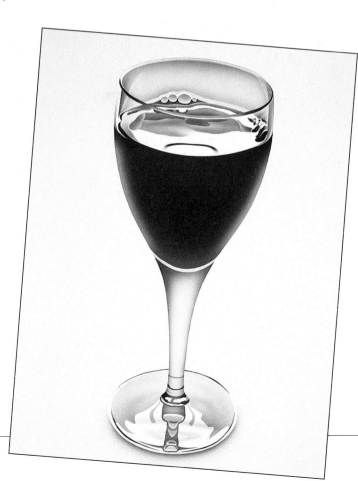

The Professionals

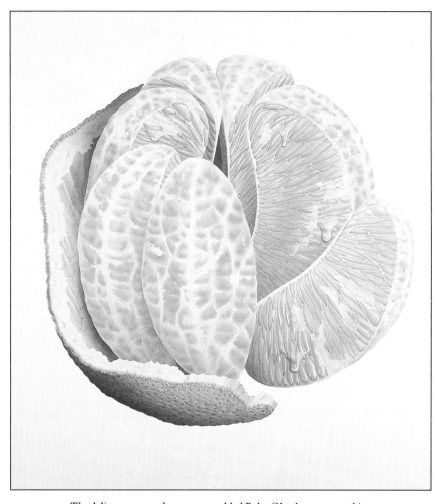

The delicate watercolour tones enabled John Charles to create this illustration. Colour was sprayed very sparingly on the segments of the orange, so that large areas of the white board show through. The peel was developed with heavier washes of yellow. A final spray of red forms a shadow under the orange and gives it a solid appearance.

The very faint spray of watercolour that John Charles sprayed inside the edges of the brandy glass suggests a reflection of the colour of the brandy and gives the artwork a more realistic appearance. A gradual build up of tone is easy to achieve with watercolour – the colour of the brandy merges smoothly from pale yellow to a rich brown.

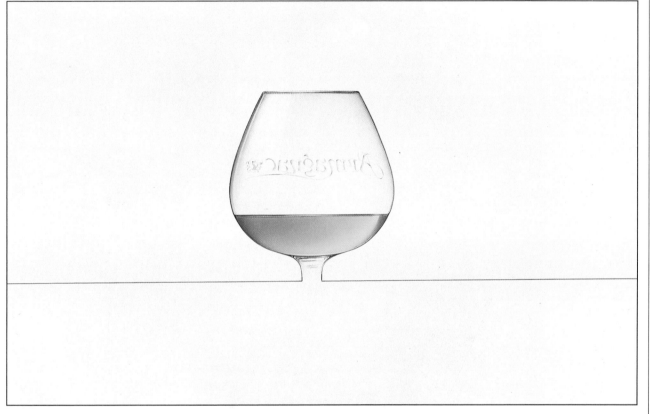

John Charles' use of watercolour shows how it can be sprayed to create anything from pale washes to intense shades. There are just two basic shades in this illustration – orange and reddish-brown – but the transparency of watercolour has allowed the artist to create a variety of mid-tones by spraying successive washes of colour.

The Professionals

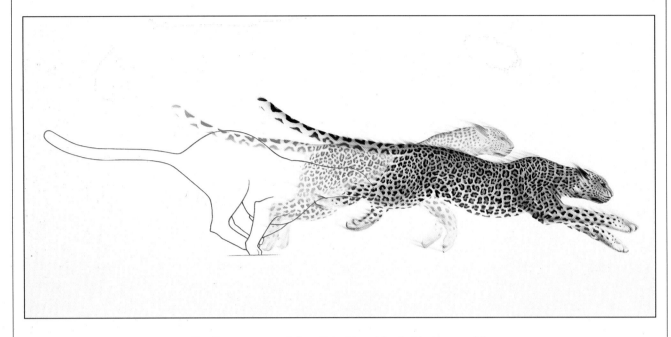

Jon Rogers cut a mask from Bristol board for the black areas of the running cheetah. He then added the brown markings freehand and cleaned away any overspray with an eraser. A separate mask, showing the position of the brown markings, was needed for the brown cheetah because the position of its body is slightly different.

Right: *Pete Kelly used a sable brush for the lines of the fish's scales, then sprayed a transparent wash of red watercolour so that the scales still showed through. The leaves were sprayed on a separate piece of paper and then stuck on afterwards. The stones were all masked individually and those in the shadows were sprayed over with a fine wash of an opaque tone.*

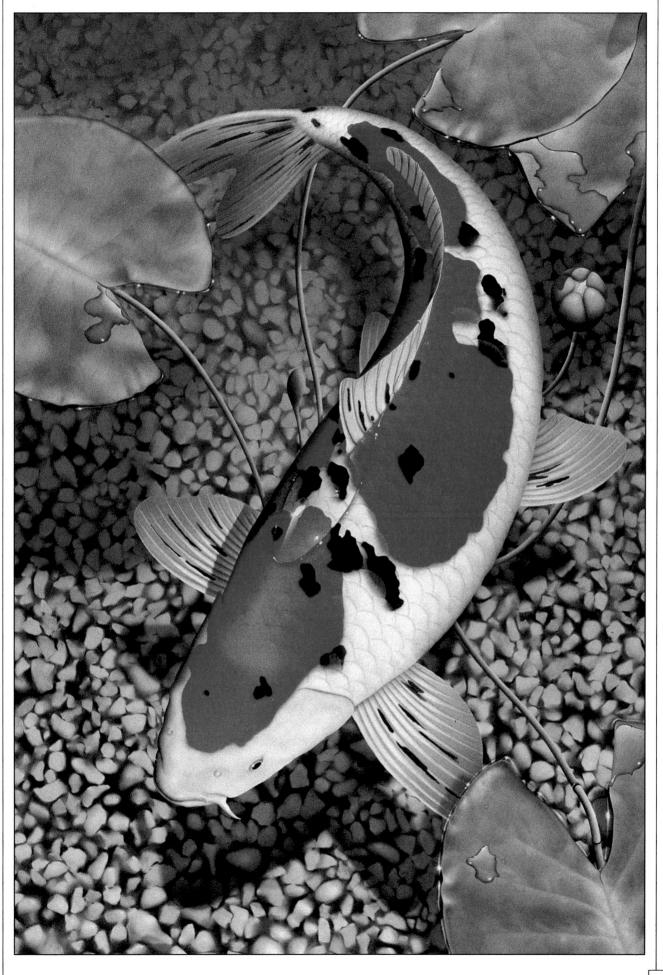

The Professionals

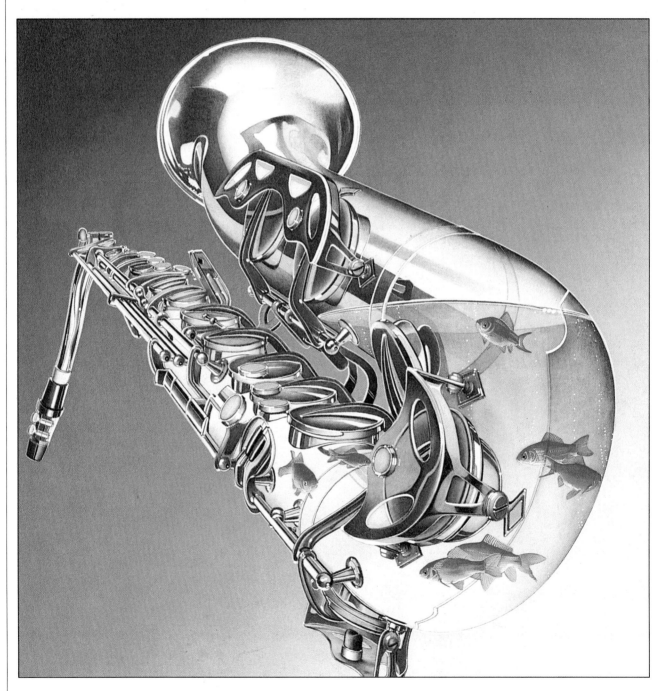

This illustration by Peter Beavis was featured in the Benson and Hedges Gold Awards exhibition. He used a mixture of acetate masks and masking film. The delicate transparent washes of watercolour in the goldfish allow the lines of the saxophone to show through. Lastly, the reflective highlights were added in acrylic.

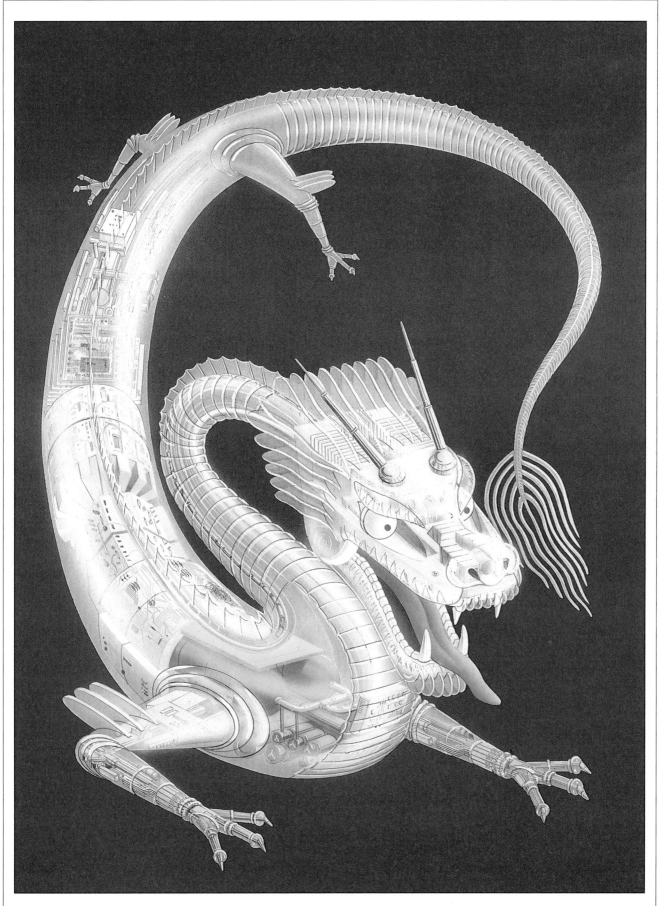

*Transparent watercolour is ideal for artworks which are intended to
have a 'cutaway' appearance. Malcolm Smith airbrushed a light
wash of white watercolour onto the body of the dragon. This wash
gives the illustration a finished three-dimensional appearance while
still allowing the details inside the dragon to show through.*

Acrylic

This sequence shows how an opaque, gouache medium can be used to create an artwork from white plus three basic shades. The masking technique uses lengths of adhesive tape as hinges so that when the masking film has been lifted from the board, its hinge holds it out of the way of the spray. This saves time, because once the paint has dried, the adhesive tape can be released and the mask simply swings back into position.

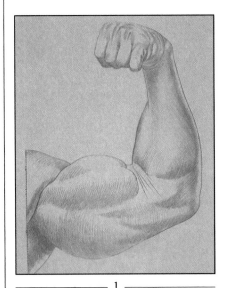

―――― 1 ――――
The detailed drawing of the arm shows the areas of light and shade that will make all the difference to the final artwork. To transfer the drawing, tape it in position on the board over a piece of tracing-down paper, carefully going over the lines with a pencil, because any small slips will be reproduced on the board.

―――― 2 ――――
Wipe the board with some lighter fluid on a soft cloth since any greasy marks will prevent the paint from adhering. Carefully spread a sheet of adhesive masking film over the whole board and cut following the pencil lines on the board.

―――― 3 ――――
Each piece of mask is removed in turn enabling you to build up the colour in specific areas. As each individual mask is peeled back, it is secured with a piece of adhesive tape so that it can be easily repositioned when the paint is dry. Within each masked area, the colour is gradually built up by freehand airbrushing.

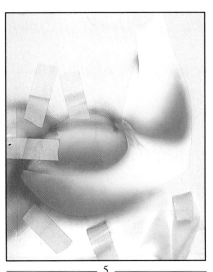

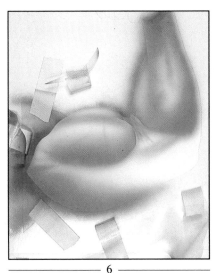

―――― 4 ――――
When the masking has been replaced, new areas can be exposed so that more colour can be sprayed. Always hold the masks that have been removed well away from the areas which are being sprayed. Any overspray which falls on the tacky side of the masking film will prevent it from sticking down again.

―――― 5 ――――
As each successive part of the artwork is uncovered and airbrushed, the details of the muscle are gradually built up. This particular shade has been mixed from red and yellow ochre, white and a small amount of sepia. Always test the colour beforehand on a spare piece of paper to ensure accuracy.

―――― 6 ――――
Refer back to the original tonal drawing to keep a check on which areas need to be densely coloured and which lines should be sharp. As the colour on the bicep and forearm is graduated from more intense skin tone through to almost pure white the three-dimensional look of the arm is already beginning to appear.

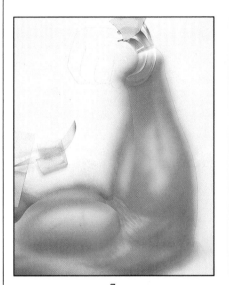

7

Mask the details of the creases on the side of the hand individually, since a small number of masks will make it easier to create the hard edges between the creases.

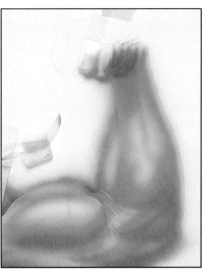

8

The fingers must also be individually masked, since the accuracy of the shading between the fingers will contribute to the realism, especially where the lighter areas of the knuckles contrast with the deeper skin tones on the fleshier parts of the hand.

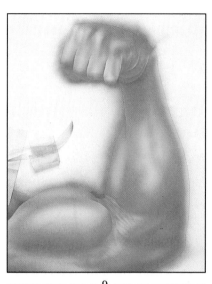

9

The first stages of spraying the lighter skin tones is now almost complete. Always refer back to the original tonal sketch to double-check whether the intensities of the light tones match.

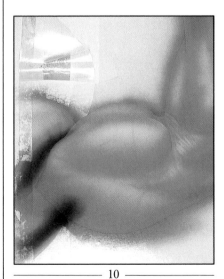

10

The next step is to airbrush the darker skin tones. Although the masked areas are the same as in the previous stages, the arm should be remasked and cut, just in case the old mask has not been replaced accurately as this would mean that the edge of the area of darker colour would show up as an unwanted line.

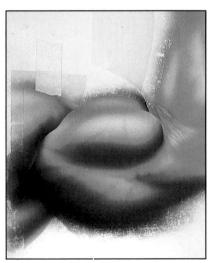

11

The build-up of the darker tones continues. This shade has been mixed from the same yellow ochre and white that were used for the lighter tones, with the addition of sepia and red ochre. It is important to add the red ochre when mixing the darker shade, or the resulting colour will look too cold.

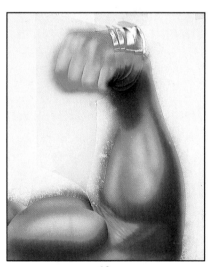

12

The arm is now beginning to look much more realistic. The dark skin tone is again sprayed freehand within each unmasked area, so that the gradation of colour can be finely controlled. The careful shading of the dark tone, and the way that it merges smoothly into the light tone, will help to give the artwork its three-dimensional effect.

Acrylic

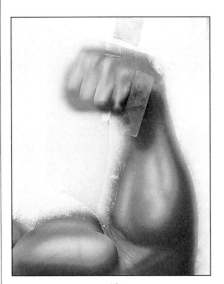

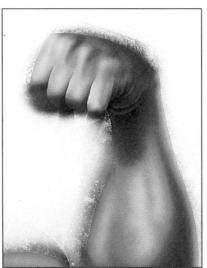

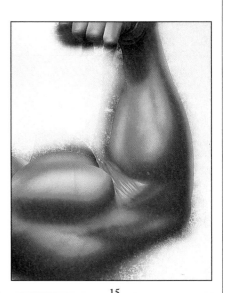

___ 13 ___

The darker skin colour is also used for the areas of shadow. It is the shadow on the wrist which will make the clenched fist appear to stand out from the board as shadows are only created by three-dimensional objects when they obscure the light.

___ 14 ___

The spraying of the darker skin tone is now complete. Once again, it is best to refer back to the tonal sketch to make sure that you have sprayed all of the different areas as intended. If any area has accidentally become too dark, it is possible at this stage to remix the lighter skin tone and overspray.

___ 15 ___

The fine lines in the crook of the arm and the highlights across the knuckles could have been created by careful masking and accurate airbrushing, but it is much easier to scratch them out with a craft knife. Work carefully along the lines with the knife and remove just enough colour without damaging the surface of the board.

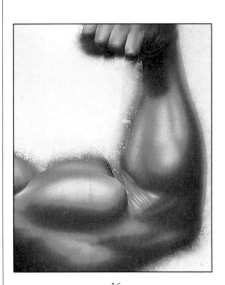

___ 16 ___

The main highlights on the biceps and on the forearm are now reinforced with white gouache. The intensity of white is greatest at the centre of the highlights and gradually diminishes towards the edges, so that the white will blend in with the skin tones and add the final touches of three-dimensional realism to the artwork.

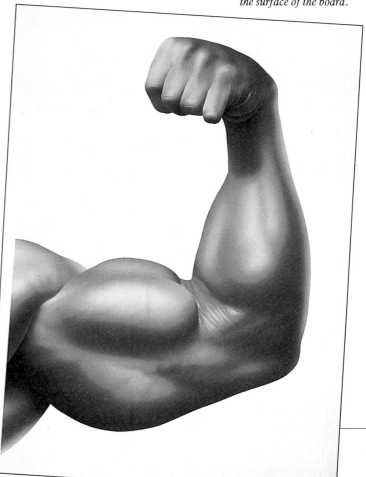

e Professionals

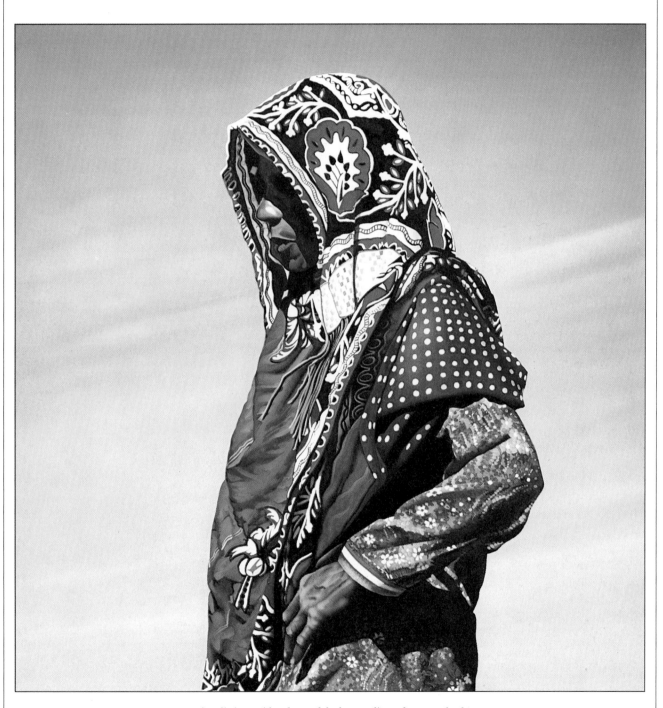

*Acrylic is considered one of the best mediums for artworks that
contain bold, bright colours, Ian Southwood hard-masked and
sprayed the skin tones and the red, black, brown and blue of this
woman's costume. The softer patterns on her sleeve and skirt were
sprayed with loose masks and finished with a sable brush.*

*Acrylic
The Professionals*

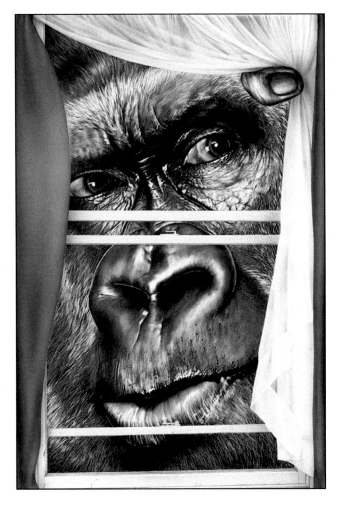

Above: *This image of King Kong was commissioned for use on a
poster. Andrew Farley used only the airbrush for the flat areas of
colour in the curtain fabrics and the window frame. Most of the
details of the gorilla's fur and the texture of his skin were picked out
with a scalpel, and others were added with a pencil.*

Right: *Acrylic colours were ideal for the brown and orange shades
of the lynx's fur. Pete Kelly sprayed them first, then used a sable
brush for the details of the white fur and the whiskers. The girl's
eyebrows were added with a pencil. The soft, fluid shapes of the
clouds make the lynx and the girl's face seem even more striking.*

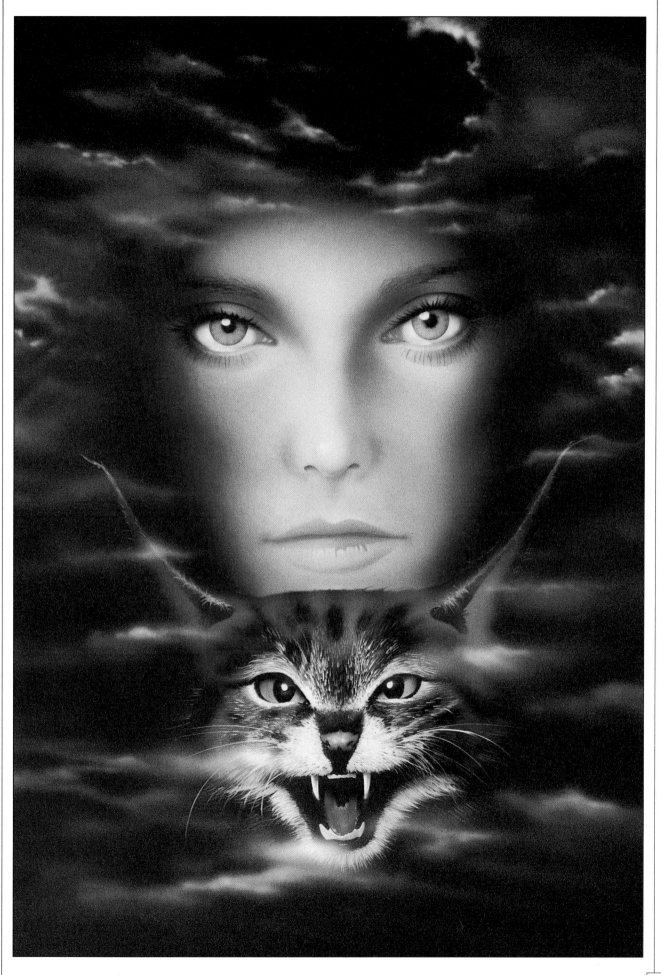

Acrylic
The Professionals

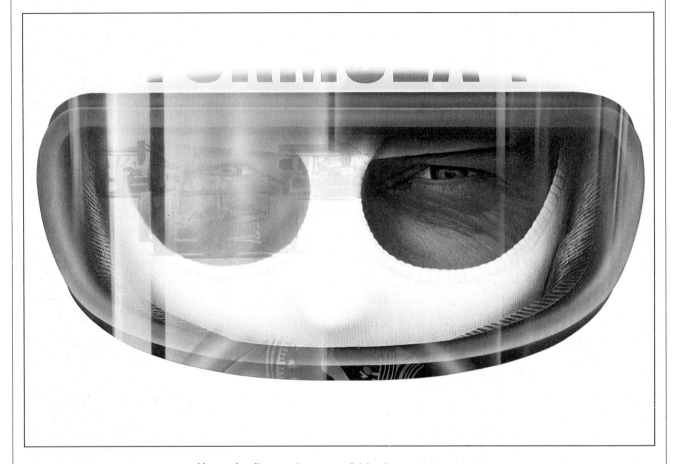

Above: *Acrylics come in a range of rich colours which are ideal for airbrushing flesh tones. Malcolm Smith used loose masks and sprayed graduated bands of white to give the visor of the racing driver's helmet its curved, reflective appearance. Note the reflected images of racing cars which are just visible on the surface of the visor.*

Right: *To create the flesh tints of Clint Eastwood's face and hand, Doug Gray used orange, yellow and brown acrylic, gradually building up the colour with thin layers of the different shades. The gun was masked with tracing paper but the reflective parts of the gun are not sprayed so that the white colour of the board can show through.*

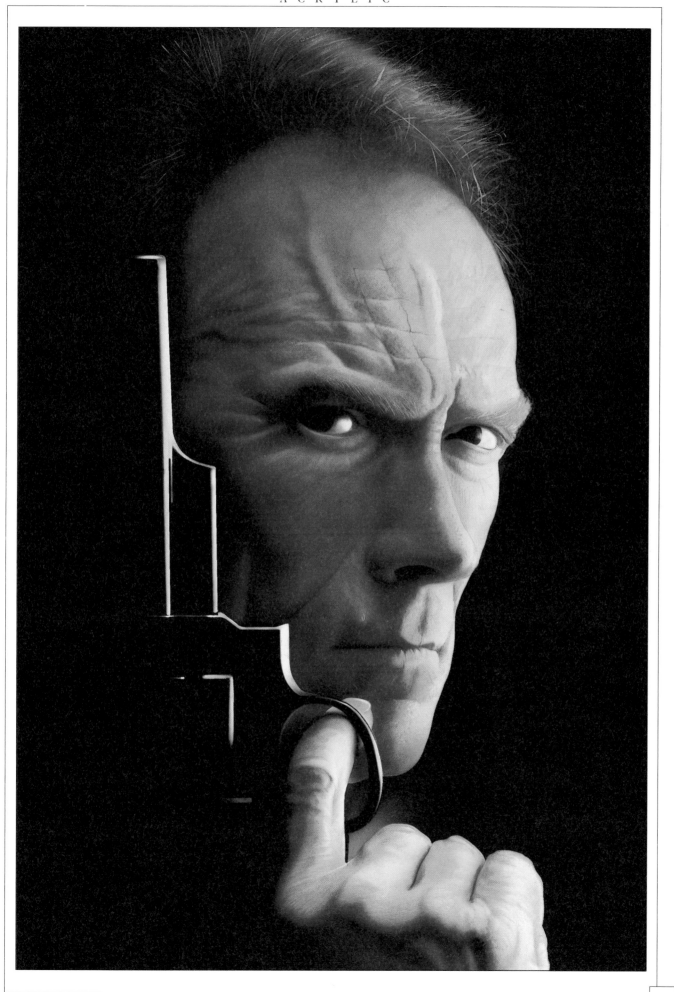

Acrylic
The Professionals

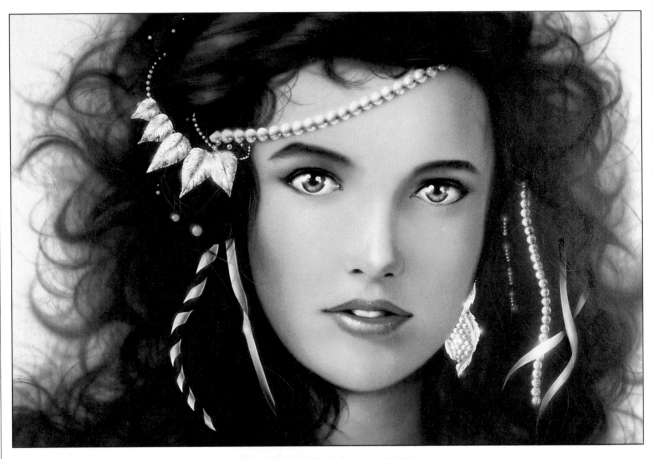

Above: *Many artists prefer acrylic for images which contain contrasting, bright colours. Jonathan Minshull sprayed almost flat washes of colour for the flesh tones of the face, and built up the hair from two basic shades. The white pinpoint highlights on the jewellery were added with a sable brush, and the soft highlights were sprayed freehand.*

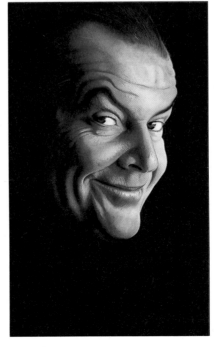

Left: *This artwork of Jack Nicholson was sprayed in acrylic by Doug Gray. He used acetate masks and developed the colour from a variety of different shades, working from light to dark. A photograph was used as a reference, but the artist introduced a slight element of caricature in order to give the illustration a stylised feel.*

The bright, vibrant colours of acrylics can really bring a picture to life. The flesh tones in this portrait by Barry Mitchell were first airbrushed and then the highlights and creases were developed with a hard eraser. Some of the contrasting colours and fine details of the hair and the eyebrows were touched in with a sable brush.

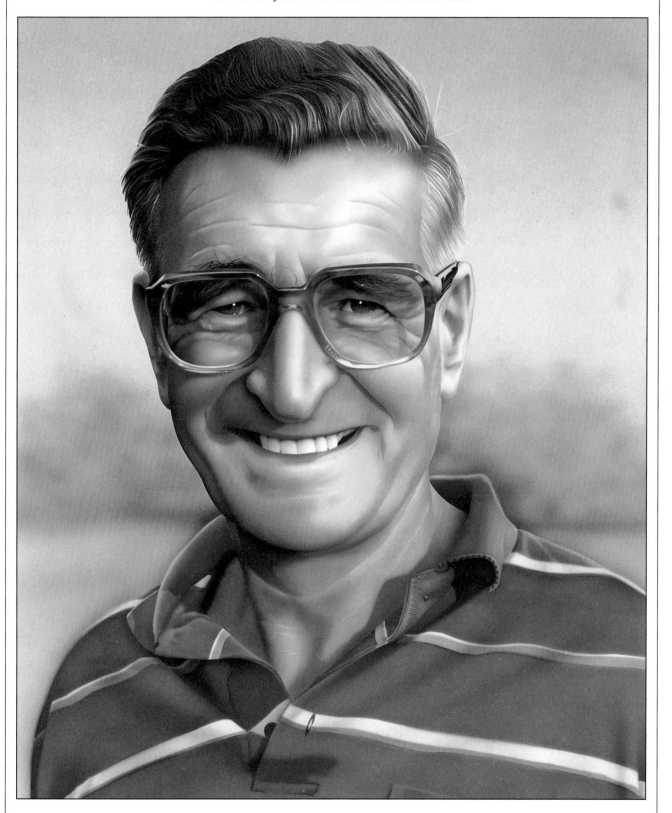

Gouache
The Professionals

Above: *This
illustration is one of a
set of six which Ian
Southwood
airbrushed as a
personal record of his
trip to the United
States. He took
photographs which he
used as reference, then
created his detailed
drawing by using a
grid. Every detail was
carefully masked before
being sprayed. The
original artwork
measured 30in × 40in.*

Left: *Ian Southwood
masked and
airbrushed all of the
main areas of colour
in the foreground.
There is some
freehand work in the
clouds, and the
graffiti on the wall
was also sprayed
freehand. The tones
in the sea have all
been achieved by the
airbrush, not with the
use of a scalpel or an
eraser.*

This illustration is another of Ian Southwood's American series. He uses masking film and paper masks – every detail of every car and boat has been painstakingly masked and sprayed. Some of the detail in the trees has been added with a sable brush, but the artwork is remarkable for the amount of detail that has been achieved solely through airbrushing.

Gouache
The Professionals

*This illustration was commissioned as one of a set of four prints.
Pete Kelly masked the whole illustration with masking film, then
airbrushed it in gouache, working from the dark areas towards the
lighter parts. The reflective highlights on the front and side of the
locomotive, which are also gouache, were sprayed freehand.*

Gouche is ideal for bold, solid areas of flat colour. Note how the tones of the red, yellow, black and blue are completely even. In this example, Jon Rogers worked out the colours he needed in advance and then laid them down with the airbrush. The lines which give form to the cloak were added with a sable brush.

Gouache
The Professionals

*This artwork is something of a rarity – it was carried out to fulfil a
private commission. The client explained his idea for the
illustration, and then Ian Southwood sketched out this image. All of
the main areas were masked, and then a little freehand work brought
out the texture of the girl's legs and the fabric of her costume.*

*Some kinds of gouache are completely opaque, but others are
semi-transparent. In this illustration by Nigel Tidman, the wash of
white on the glass gives solidity but still allows the fruit inside to
show through. The creamy shade of the ice cream, on the other hand,
has been sprayed over the rim of the glass and completely conceals it.*

Gouache
The Professionals

Above: *Pete Kelly masked this artwork with masking film, then used a ruler to cut along the horizontal lines. Flat washes of gouache give the shapes of the tree and the landscape their stylised, solid appearance, and the stripes of colour give an impression of depth. The graduated tones in the clouds and in the sky were sprayed freehand.*

Right: *The light shades of the fish were airbrushed in gouache. Jerry Preston graduated the intensity of the orange and yellow colours on the fish – with the brighter shades nearer to the light source – to give them a more three-dimensional look. Note how the leaf floating on the water gives the whole illustration an impression of depth.*

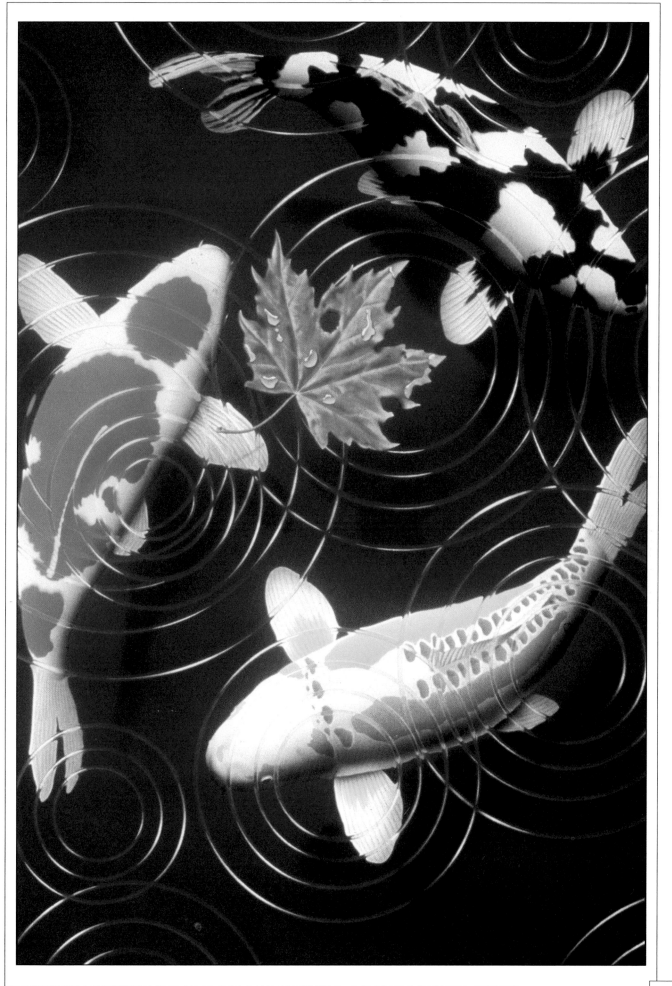

The Professionals
Ink

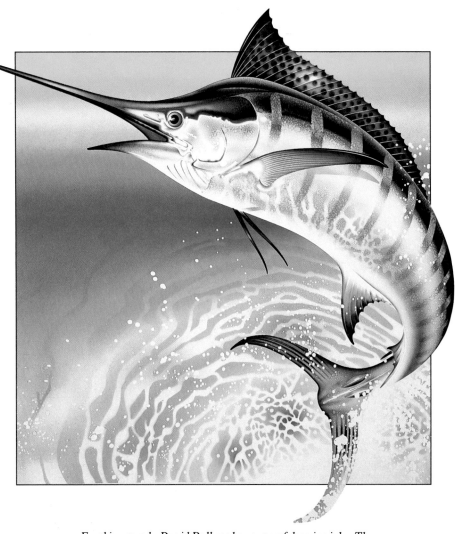

For this artwork, David Bull used waterproof drawing inks. The hard edges were masked with masking film, and a paper stencil was used for the ripples in the water. For the droplets of water, he flicked masking fluid at the board with a toothbrush. You can never quite predict the result, but the dried fluid can always be lifted off which enables you to try again.

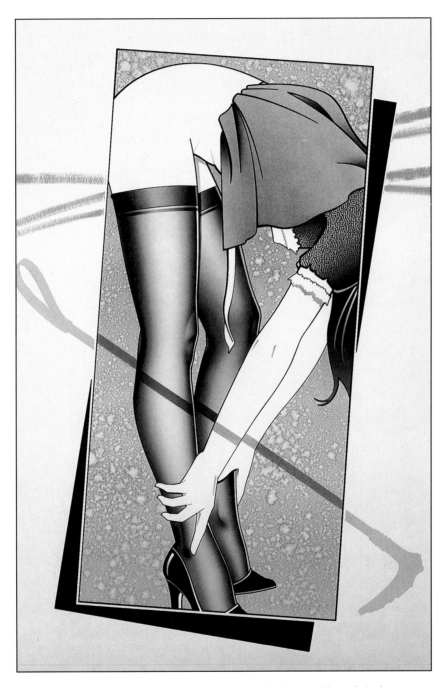

The outlines of this artwork were originally drawn with a technical pen, then David Bull added colour with inks. Note how the transparent wash of purple on the legs makes the underlying black look warmer giving shape to the legs. The blouse was created from a piece of ready-patterned film which was stuck down and lightly airbrushed.

Ink
The Professionals

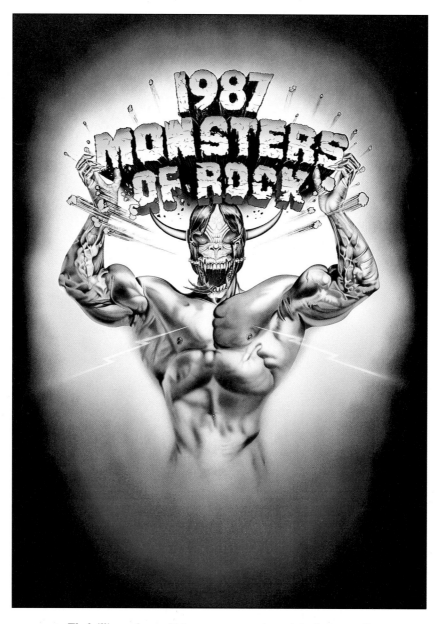

*The brilliant colours which attract many artists to inks show up well
in this illustration by Mark Wilkinson. The transparency of inks
allowed the colours of the chest to be gradually built up with brown
and green, to achieve a variety of different shades from light green
and light brown to a dark, almost black shade.*

Chris Burke airbrushed this artwork in ink because of the vibrant tones that can be achieved. He drew the image directly onto the board in pencil, and then masked it and sprayed the colour. The shapes of the tie were either masked with masking fluid, flicked with a toothbrush, or dabbed with paper tissue.

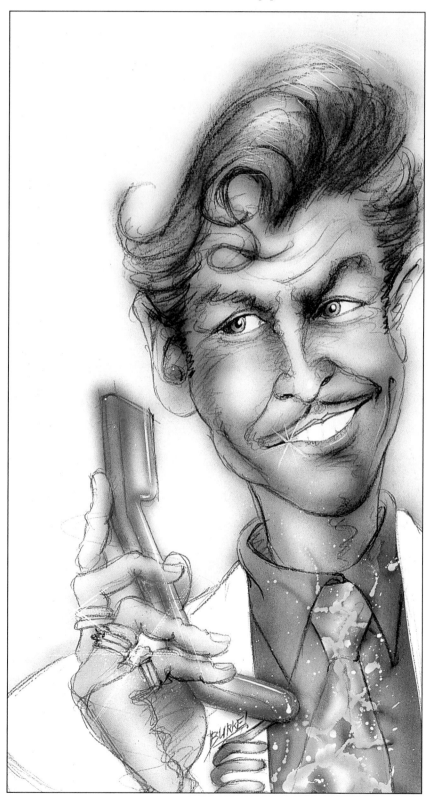

SUPPORTS

Any surface onto which you airbrush is called a support, or ground. Paper and board are the most commonly used supports, and there is a vast range on the market. Your choice will depend on the image being produced and the techniques involved – whether broad and largely freehand, or detailed and controlled, with much use of masking film. In general, if you are creating a very detailed artwork, it will look better on smooth board or paper, while an artwork that has broader areas of colour and softer edges may actually gain in character by being sprayed on to a support that has a textured surface.

There is now an increasing trend for artists to work on acid-free papers and boards. These are designed to last longer than conventional supports because they do not contain the chemicals which cause decay and discolouration. Acid-free products are also referred to as 'conservation grade' or 'museum quality'.

When using a paper or board for the first time, it pays to do some practice masking and spraying on a test sheet before starting on a piece of work, to familiarize yourself with its handling characteristics. For example, textured papers and boards are difficult to mask because of the irregularity of their surface. With cheaper quality papers and boards, you may find that the surface fibres tend to lift off when you remove masking film after use.

BOARDS

The best support for most airbrush work is illustration board, which is available in a variety of types and sizes. Fine art boards such as CS10 board and line board are composed of a layer of high-quality paper bonded to a pre-stretched support board to maintain flatness and resist distortion. These are tailor-made for airbrush work, being flat, smooth, hard and very white. They are also tough enough to withstand scraping and erasing, and will not throw off fibres when masking is peeled away. Another advantage is that masking film adheres evenly to the board, so there is less risk of paint seeping under the mask. Some illustration boards are double-faced, giving you twice the area to work on for less than twice the cost.

Bristol board is a laminate made from several sheets of paper. Its slightly softer surface lends itself to brush and wash work which may be used in conjunction with airbrushing.

You can also buy watercolour boards, which have more surface texture than illustration board. These are suitable for a loose, freehand painting style but not for detailed and precise work. The textured surface prevents masking film from adhering uniformly and spray may creep under the edges of the mask. Watercolour boards are designed for use with soft sable brushes, and the surface may become fibrous if it is rubbed or scratched back.

PAPERS

Papers are cheaper than boards, so they are suitable for your initial experiments, but they lack the strength of boards and are more prone to creasing. Some papers are also liable to distort when heavy washes of paint are applied, and may need to be stretched before use (see below). It is possible, however, to buy pre-stretched papers, either in sheets or in blocks, which are resistant to distortion.

If your work includes a lot of fine detail, or involves heavy use of masking, scraping or erasing, then the best surface to work on is a fine line art paper or CS10 paper. These have a smooth, non-absorbent surface that lends a crisp definition to your work and generally do not require stretching.

Watercolour papers have a pleasantly textured surface which is enhanced when paint is airbrushed over them and can add character to your artworks. A smooth, hot-pressed paper will give a 'photographic' appearance, while a rougher grade of paper creates more of an 'old master' feel. However, watercolour paper is soft and fibrous, and is therefore less suited to work involving masking, scraping and erasing.

STRETCHING PAPER

Most papers, particularly the cheaper grades and lightweight papers, tend to buckle or 'cockle' when dampened, for example when a heavy wash of paint is applied. To prevent this, the paper should be stretched and taped down to the drawing board before use.

To stretch a sheet of paper, first wet it on both sides, either by dampening it with a sponge or by immersing it briefly in a dish of cold water large enough to take the sheet of paper without risk of creasing it. The paper should be evenly moist, but not soaking.

Carefully shake any drops of water from the paper, then lay it flat on the board. Take a length of brown paper, gummed tape, several inches longer than the longest edge of the paper, wet the gummed side with a sponge, and tape the paper to the board. Half the width of the tape be on the paper, half on the board.

Gently pull the paper flat, but do not attempt to pull it taut, and tape down the second long edge. Finally tape down the two shorter sides. Do not worry if the paper wrinkles at this stage – it will flatten out naturally as it dries.

Allow the paper to dry flat, at room temperature. When it is completely dry, it is ready for airbrushing – do not attempt to work on a semi-damp surface.

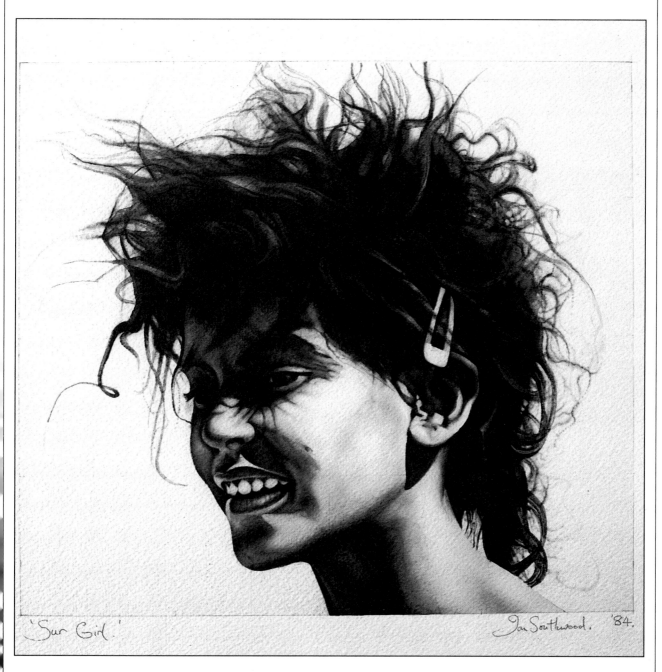

'Sur Girl.' Ian Southwood. '84.

The type of support can often make a large contribution to the success
of the finished artwork. Here, Ian Southwood used a heavily
textured paper to give this illustration a 'painted on canvas'
appearance. The texture of the paper shows clearly in the
background and in the flesh tones, but is less noticeable in the dark
areas of the girl's hair.

Many art suppliers stock paper and board in a variety of grades, from completely smooth to heavily textured. By making a careful choice, you can use the surface texture to enhance the artwork.

—————— 1 ——————

This artwork has been airbrushed on CS10, which is available both as board and individual sheets. It has an almost completely smooth surface, ideal for artworks which are to have the classic, glossy, airbrushed look. CS 10's smoothness enhances any artwork that includes chrome or metallic surfaces.

—————— 2 ——————

There are several grades of watercolour paper. This is one of the smoothest, with just a little roughness on the surface, which adds a little texture to the artwork and makes it look slightly less 'machine made'. The surface of the paper looks almost like fine fabric, making it suitable for showing clothing.

─────── 4 ───────

*By now, the apple looks much less realistic,
since in real life, it would be shiny. Paper of
this grade is suitable for artworks of
landscapes. Even though it is not smooth,
masking film will adhere to this paper
adequately and you should not get any stray
colour finding its way under the mask.*

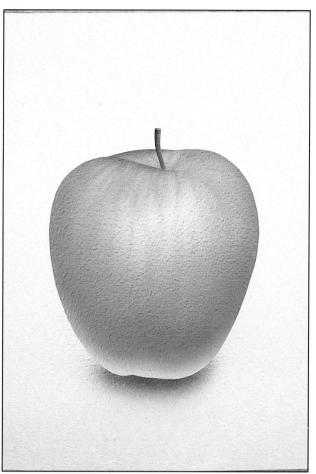

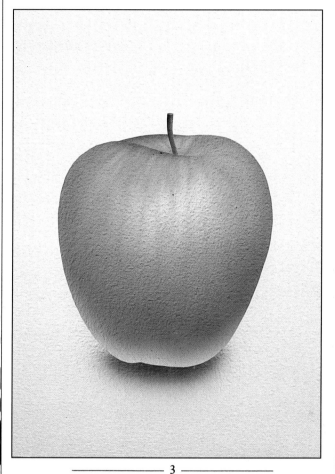

─────── 3 ───────

*The next grade of watercolour paper has a
much rougher-looking surface, which can be
used to add realism to artworks of more
textured subjects, such as the bark of a tree
or the walls of a stone house. The artwork is
beginning to look much less as if it has been
produced with an airbrush and almost seems
to have been painted with a sable brush.*

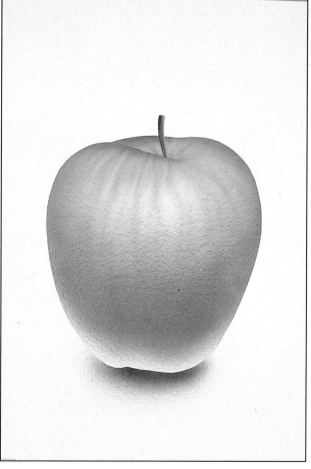

─────── 5 ───────

*This degree of surface texture almost
simulates the effect of canvas, making it
ideal for an airbrushed 'old master'. This
coarse grade of paper produces such heavily
textured artwork that it is difficult to create
realistic highlights, because many objects
with rough surfaces do not often reflect light.*

The Professionals

Gavin McCleod used CS10 board for this illustration. The hard, smooth surface of this board makes it ideal for artworks in which the highlights are formed with hard erasers or scalpel blades. A hard eraser was used here to pick out the reflections on the car's bodywork and suspension, as well as the bright lines on the road.

*Chris Burke used non-porous board for this illustration. The pencil
outlines were drawn directly onto the board, then the white areas
were masked and the darker areas sprayed. A hard, non-porous
surface will make every tiny pencil mark show up clearly – but it is
more difficult to erase any unwanted lines.*

Spatter

EFFECTS

1
The basic texture of stone can be sprayed using an airbrush fitted with a spatter cap. Different effects can be achieved in two ways. One is to vary the pressure delivered by the compressor, as a lower pressure creates more spatter. The other is to use different thicknesses of paint, as thicker paint is harder to atomise and will spatter more readily.

2
As the density of the spots of paint builds up, the surface of the stone begins to take on texture. Here, some lighter greys have been sprayed on, still with the spatter cap, so that the amounts of the different colours are evenly balanced across the surface of the stone.

3
Next, spray more paint in layers, until the colour reaches the density required. The paint is not sprayed evenly – the colour is concentrated in the areas of stone which will look darkest in the finished artwork.

4
Spray the shadows on the stone with the normal nozzle of the airbrush, not the spatter cap. Use a transparent dark grey, which will add shape and definition to the stone without covering up the texture of the stone created by the spatter. The stone is now starting to look three-dimensional.

5
Now remask the completed granite stone and expose the sandstone. Build up the texture of the sandstone by airbrushing with a normal nozzle, not a spatter cap. Use a low air pressure so that the spray gives a slightly grainy effect.

It is well worth mastering the full range of effects that the airbrush can produce. Once familiar with the full capabilities of the airbrush, you can practise and develop these basic effects, to create your own individual style.

—— 6 ——

The sandstone needs horizontal stripes to make it look realistic. Build these up a layer at a time by freehand airbrushing. They will gain much of their effect from their unevenness – completely even and straight stripes would look most unrealistic.

—— 7 ——

The sandstone starts to look three-dimensional when more horizontal lines are sprayed in dark sepia. These dark lines follow the general direction of the lighter-coloured stripes and fit into the contours of the perimeter of the stone, creating shadows where the stone is concave.

—— 8 ——

Remask the sandstone and remove the masking film from the areas around the stone. Small shadows, sprayed freehand underneath the stones, help give the impression of solidity. Now all that remains is to create some soft highlights with an eraser on the lighter parts of both the granite and sandstone.

Starburst

_____ 1 _____

The artwork shown here has been airbrushed onto black paper. If you are spraying a starburst in just one section of an artwork, it is easier and quicker to spray that section with opaque black first. The first step in making a starburst is to lay a sheet of masking film over the paper and then to cut a cross in the centre of the film.

_____ 2 _____

Next, airbrush some opaque white over the centre of the cross so that the density of the colour is greatest there and gradually fades as it gets further from the centre. The star will look most effective if the centre is pure white. The points radiating from the centre can be any length you like.

_____ 3 _____

Once you have removed the masking film, the basic star is revealed. There are some types of artwork for which this type of star is ideal: a simple Christmas card, for example, might look over-decorated if you created an ornate starburst. Notice how the centre of the star seems to glow and radiate light outwards.

_____ 4 _____

No masking film is used for this next stage, so you will have to take great care. To create the basic starburst effect, airbrush some opaque white onto the centre of the cross, covering it densely in the middle and leaving the edges blurred. The soft edge of the white spot makes the starburst look as if it is twinkling.

_____ 5 _____

If you want to develop the starburst further, you can make another set of radiating lines at an angle from the first set. Using the same piece of masking film, make sure that the centre of the new cross lines up exactly with the old one. The new points should be at 45 degrees from the existing ones. Spray some more opaque white over the centre.

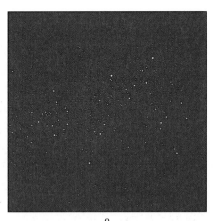

—— 6 ——

With the masking removed, the starburst is revealed in all its glory. If the colour has not extended equally along all the points of the cross, and it looks unbalanced, you can make it more symmetrical by remasking it and airbrushing with more opaque white until all the points are evenly coloured.

—— 7 ——

As a further refinement to the starburst, you can add a halo around the central white area. To do this, lay a circle of masking film over the centre of the starburst and spray a wash of white around its edges, so that the points of the cross and the spaces between them are lightly coloured.

—— 8 ——

This starfield – another airbrush effect – has also been created on black paper. Use a spatter cap for this, if your airbrush has one. Alternatively, you can dip a toothbrush into the white paint and flick it at the paper, making a shower of spots of paint.

—— 9 ——

You can embellish the starfield using the techniques used to make a starburst. Here, some of the white spots have been given a glowing, starburst effect with a soft-edge airbrush dot. The scene now has much more variety and interest, with effects ranging from plain white spots to stars with glowing halos.

Reflective Surfaces

1

Highly polished surfaces, such as chrome or glass gain their effect by reflecting light and the images of other objects. In this sketch of a pinball, the surface has been shaded to show where the reflections are to be. When the reflections on your own sketch look right, you can cut out the masks.

2

The mask was cut so that the dividing line between the two halves of the sphere had an irregular edge. Notice how the line curves smoothly upwards at the edges – emphasising the pinball's shape. The lower part of the masking film was removed and a wash of dark sepia watercolour was airbrushed along the reflected 'horizon'.

3

The colour of the lower half of the artwork was built up with red and yellow ochre. You can see how the dark sepia beneath this still shows through and that the intensity of the colour has been graduated smoothly. This helps the ball look three-dimensional.

4

The lower part of the ball was then remasked and the upper part exposed. It was sprayed with sky-blue watercolour, using the sketch as a guide to the intensity of the colour. The lightest areas of the pinball have almost no paint on them.

5

The blue was built up to give balance between the top and the bottom. It did not matter if any blue watercolour fell on the white highlight at the top, as this highlight could be reinforced later on, using an eraser.

he Professionals

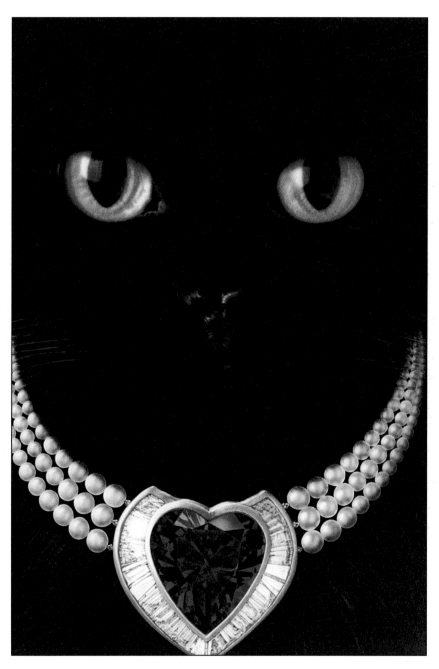

*The contrast between the dark fur and the bright eyes and jewellery
gives this image its impact. Andre Farley sprayed a wash of
black and then picked out the details of the fur with a scalpel. The
main outlines of the brooch were masked with masking film, then
loose paper masks were used for the reflective facets of the jewels.*

The Professionals

*Ian Southwood worked as a freelance artist in Oman and was
commissioned by the Sultan. The original inspiration for this
artwork was from a photograph which the artist had taken himself.
The airbrush style has captured the hard, barren Omani desert set
against the heavy skies. The texture of the paper adds interest to the
whole scene, particularly the sand.*

Andrew Stewart airbrushed this science-fiction scene for a video cover. In its final form, this artwork serves as a backdrop for the lettering on the cover. This view of the clouds, as seen from above, was taken from a video on aircraft. The fluffy white clouds and the rays of light were sprayed freehand.

The Professionals

The airbrush is ideal for creating scenes which combine a high degree of realism with a stylised presentation. Nigel Tidman airbrushed the piano keys in an almost photo-realistic style. The sheer perfection of the strawberry, together with its reflective surface, make it clear that this is in fact an artwork and not a photograph.

It took Doug Gray three attempts to get the sauce bottle to smash just as he wanted! The basic red tones, as well as the darker shades and the shadows, were airbrushed in gouache, then the lighter reflective areas were sprayed in acrylic. Finally, the details of the surface texture were painted with a fine sable brush.

The Professionals

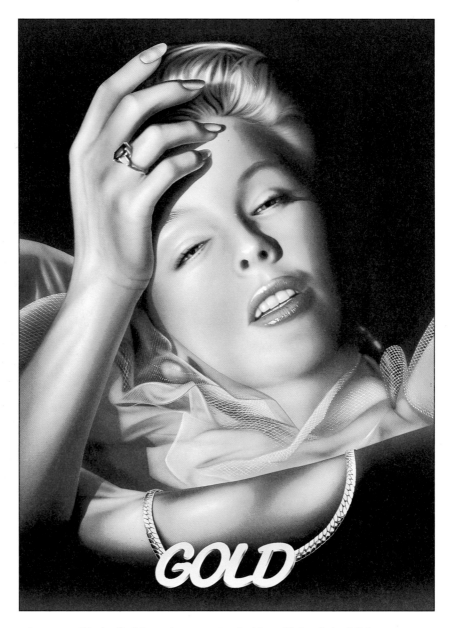

The detail of the netting was painted with a sable brush, but Nick Farmer used an airbrush and loose card masks to form the folds in the fabric. The colour of the gold necklace was developed from white, yellow and ochre. The necklace looks particularly shiny and reflective where the dark reflections are seen against the light edges.

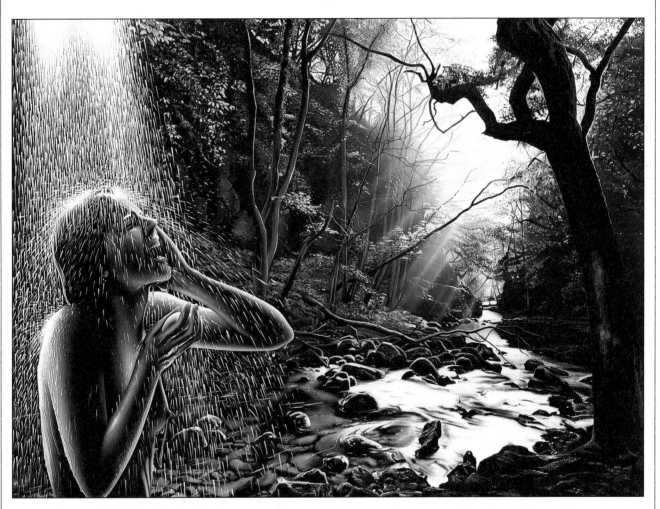

*Nick Farmer built up this artwork in stages, starting with the parts
of the image that are farthest away, like the hill and foliage in the
background, and finished with the tree in the foreground. The
airbrush was used to spray the broad areas of colour, such as the
greeny brown of the hillside and also to blend together the different
elements.*

CORRECTION TECHNIQUES

—— 1 ——

Here, masking film was supposed to create a sharp edge, but some paint has crept under it, making it look ragged. This may have been because too much paint was used or because the masking film was not laid completely smoothly, leaving some areas where the film was not making proper contact.

—— 2 ——

Repair the damage by gently scraping away the unwanted colour, using a curved scalpel blade. Work along the edge of the paint, removing the excess colour a little at a time. If the ragged edge is quite long, use a ruler as a guide to make sure you do not accidentally create a crooked line.

—— 3 ——

This area of graduated tone was developing nicely until some red paint was accidentally sprayed on an area that was meant to stay light.

—— 4 ——

The problem can be put right quite simply. Overspray the stray paint with white gouache to obliterate the offending mark. When it is dry, the process of producing graduated colour can proceed as before.

There is not an airbrush artist in the world who has never made a mistake. Errors and accidents are inevitable (and have a nasty habit of occurring when the artwork is almost complete) but there are a number of quick and effective techniques which can save the day without your having to resort to a complete restart. More importantly, though, a careful and methodical approach to airbrushing will keep errors and accidents to a minimum.

General cleanliness is most important for the success of your work. It is a wise precaution to wash your hands before starting work, as any grease on your skin can easily be transferred to the support you are working on. Even an invisible amount of grease on the surface will reduce the ability of the paint to adhere, resulting in an uneven finish. Similarly, if you get any paint on your hands, wash it off immediately. Avoid marking the support by handling it only lightly at the edges. While working, it is a good idea to rest your hand on a piece of clean paper to further protect the support beneath.

When you are not actually using the airbrush during a spraying session, either place it in an airbrush stand away from the artwork, or lay it carefully down so that it cannot overturn and spill paint onto the working surface. Also, make sure that the air hose is well out of the way so that it cannot be accidentally dragged across the artwork.

If the worst should happen and paint or ink is spilled on to the artwork, you will have to act quickly. Use a soft cloth or a wad of paper tissues to form a dam so that the paint cannot spread any further, then mop up all the paint from the surface. When the spilt paint has dried, you can judge whether any of your work can be salvaged. If most of the artwork is still intact, you may be able to spray over the damaged area with opaque white, then reconstruct the image.

It is worth repeating here that routine cleaning of the airbrush is vital to keep it working smoothly and accurately. Problems such as uneven, spattered spray are often caused by an obstruction in the air cap or by the needle sticking on dried particles of pigment, so make sure that the needle and nozzle are cleaned every time you lay down the airbrush, even if only for a few minutes.

When changing to a new colour, always flush the airbrush through with water or solvent to get rid of every trace of the old colour. When you have refilled the airbrush with the new colour, begin with a test spray on a piece of scrap paper before you begin spraying on the artwork itself.

The aspect of airbrushing that leads to most disasters is probably masking. If masks are not accurately cut, the finished artwork will never quite live up to your expectations. A supply of sharp scalpel blades is essential, as a worn blade will tear at the masking material rather than cutting it. If you make a mistake in the actual cutting of the mask, it is very difficult to make any corrections – it is better to take a new piece of masking material and begin again.

When using masks, avoid spraying too heavily and hold the airbrush at right-angles to the surface. Otherwise paint may build up at the edges of the mask, or a thin white line may be left where the spray has passed right over the edge of the mask. A loose mask which is carelessly laid on the surface may allow colour to bleed under the edges, resulting in a ragged finish. If you are using a hard, smooth surface, such errors can be removed by gentle scraping with a scalpel when the paint is thoroughly dry.

Accidents Can Occur

When starting out, sooner or later, something is bound to go wrong. There are a number of common problems which if you learn to identify, can usually be overcome and put right.

— 1 —

The lines are uneven and broken. This happens in a number of ways: the paint may be too thick so that it cannot atomise properly; the needle may need cleaning; the nozzle may be damaged or the flow of air from the compressor may be irregular.

— 2 —

Here, when the layer of masking film was peeled off, it lifted the surface of the paint underneath. Some paints should be sprayed with fixative to prevent this, but be careful as some fixatives turn masking film into mush.

— 3 —

There is far too much paint on this surface and it has formed a pool. If the excessive wetness has not distorted the surface, you should be able to rectify matters by carefully dipping a paper tissue into the pool and allowing it to soak up the excess paint.

— 4 —

This problem has been caused by spraying too much paint. The surface is so wet that paint has crept under the edge of the masking film, giving a ragged line when this is removed. Notice how there has been a build-up of paint along the edges of the masking film.

———— 5 ————
You might want this grainy effect, but it can happen accidentally for a number of reasons. The air pressure from the compressor could be too low, the nozzle or needle may be dirty or damaged or the paint may be too thick to atomise completely.

———— 6 ————
This kind of spidery effect can be caused by spraying too much paint, or alternatively, the pressure from the compressor may be too high, which means that the surface is too wet and the paint is blown about.

———— 7 ————
This is a heartbreaking problem – especially if it happens when the artwork is nearly finished. There were greasy fingerprints on the board's surface, but they were not visible until after paint had been sprayed over them. Always start work by wiping the board over with some cotton wool soaked in lighter fluid.

———— 8 ————
This kind of spatter is often caused by overfilling the paint reservoir. Paint can run down the outside of the airbrush and get blown onto the paper. This can also happen when you are painting a large area, because droplets of paint may collect in the nozzle and then blow onto the surface.

TECHNICAL ILLUSTRATION

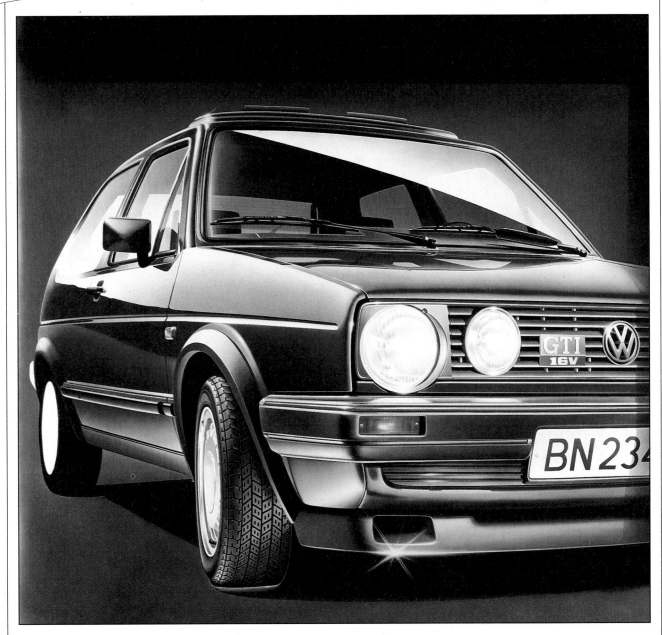

This artwork originally appeared on the cover of a VW accessory brochure. Paul Higgens used a photograph as reference and followed the details faithfully. The original illustration was airbrushed in gouache on a board measuring 30 in × 40 in. A sable brush was used for some of the detail of the tyres.

John Harwood created this artwork from photo references. The chassis was sprayed in acrylic, using hard and soft masks and the highlights added with white gouache and a sable brush. The outline of the body was originally drawn separately in black ink, then converted by a photographic process to a coloured image with flare around the green lines.

The Professionals

The original clock was dismantled and drawn in this exploded state by Keith Hume. The slight spatter effect on the bronze clock case was achieved by using slightly thicker ink with the compressor pressure lowered. The letters and numbers on the dial were added with a sable brush and a technical pen, but the reflected numbers were airbrushed.

Left: *Keith Hume used inks for this illustration. The battery and the headphones were drawn from life, the two elements being juxtaposed to give the sureal image. All of the lettering was drawn out, then masked and airbrushed – this was an intricate job even though the original artwork measures approximately 12 inches by 9.*

Left: *This aircraft, based on Concorde, combines technically accurate elements with some artistic licence. Paul Higgens used soft masks for the clouds, and also masked the 'speed lines' at the tail of the plane which he sprayed lightly with gouache. The small details on the fuselage were added with a sable brush.*

The Professionals

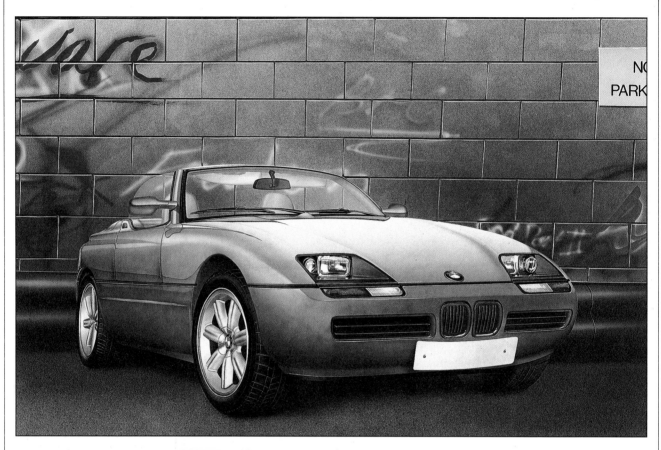

Above: *Keith Hume took a main photograph of this BMW to use as an overall reference, and a number of photos of the details of the car. On the tyres, the tread was picked out with a technical pen then the highlights were sable brushed in gouache. The spatter effect of the tarmac was achieved by flicking white gouache with a toothbrush.*

Left: *Although Paul Higgens airbrushed this artwork in gouache, he also incorporated some sable brush work. The illustration faithfully follows a photograph in every important detail of the scene, except where the artist took the opportunity to make a few cosmetic changes, such as cleaning up the surface of the road.*

Above: *Paul Higgens took photographs of several trucks as reference for this artwork, which contains elements from various different vehicles. The black lettering was done with a technical pen, but the coloured letters were masked and prayed in gouache. A sable brush was used for the detail on the tyres and around the windows.*

Left: *In this artwork, Nick Farmer combines the appearance of rubber, paint, chrome and tarmac. The surface of the tyre was airbrushed with a combination of brown and blue, then black was sprayed over. The highlights on the tyre were rubbed back with an eraser which gives the tyre its slightly rough, grainy look. The details were then picked out with a sable brush.*

LETTERING

Above: *The lettering in this picture was designed to give a 'neon sign' appearance. Jon Rogers masked all of the lettering with masking film, including the pink within the white outline of the main letters. Note how the size and spacing of the letters has been graduated to give the illustration a feeling of depth.*

Top: *This illustration was commissioned for a jeans logo. Jon Rogers used inks and a mixture of hard and loose masks, then picked out the highlights with a scalpel. A trick of the trade – the spatter effect in the yellow 'asteroid belt' was achieved by wrapping a length of masking tape around the nozzle of the airbrush!*

Phil Dobson worked as a signwriter for three years before going to college. He based the lettering in 'the golden age of' on the floor indicator of an art deco hotel lift. He drew the other letters with a technical pen, using a ruler and compasses, and then airbrushed the lettering to achieve a chrome effect.

The Professionals

Above: *Jon Rogers' artwork shows how the starburst technique can be used to form letters. The background was sprayed with blue ink, and then a combination of freehand airbrushing and acetate masking built up the image. The same acetate mask was used for several of the stars – when a lot of paint had accumulated, the mask was washed and then used again.*

Top: *When he was planning this illustration, Jon Rogers spent more time on getting the lettering right than on the actual airbrushing. When the design was complete, it was very accurately traced to show all of the highlights. The colours were then steadily built up, and acetate masks were used to form the highlights.*

This artwork was created for the English magazine 'Time Out' by Ainslie MacLeod. He specialises in cartoon work and used this style instead of conventional lettering techniques. This illustration, which was airbrushed in Indian ink and transparent inks, won first prize for the best consumer magazine cover of the year.

CREATING THE IMAGE

3

This shot was used as a reference for the mountains in the background. The misty atmosphere and the way the light plays on the mountains is just right – the mountains in the finished artwork will also have this misty look and give the same impression of stretching endlessly into the distance.

1

When you are planning an artwork, make several rough sketches so that you can see how your ideas will work out on paper. A sketch like this one gives the general feel of the artwork, showing the relative proportions of the various elements in the picture.

2

Use accurate pictures as references when you are preparing the final drawing. In this example, the hand and magnifying glass have been set out more or less as shown in the 'idea sketch' and photographed. The background of the photograph is not important.

4

If the reference picture is the wrong size for the finished artwork, resize it, using a grid. Spread a sheet of masking film over the photograph and draw a grid on it. Here, only the hand needs to be resized, as the glass is just a circle and can be drawn to any size using a pair of compasses.

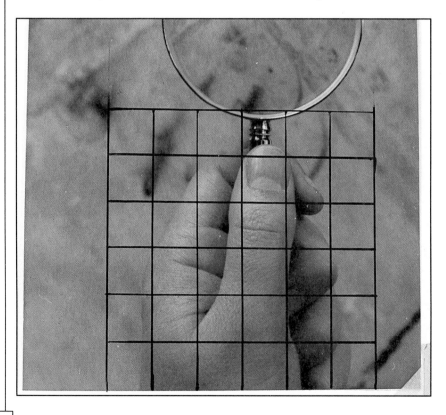

Many artworks owe their success to a number of different techniques. The combination of visual effects not only adds interest to an illustration but demonstrates the artist's versatility. This artwork uses many of the approaches and techniques which have been described in this book.

— 5 —

Next, draw a grid of the right size on a sheet of detail paper. Here, the grid is about three times the size of the one on the photograph. The grid is drawn at an angle so that the hand in the final drawing will be more nearly vertical than it is the photograph.

— 6 —

Transferring the drawing across from the photograph is quite straightforward. Proceed square by square and the proportions of the hand will automatically come out right. When you have finished, smooth the lines out with a pencil.

— 7 —

To set the compasses for the circle, compare the relative sizes of the hand and the glass in the 'idea sketch' and use these proportions. For future reference, the centre of the circle has been marked by two guidelines outside the main frame of the composition.

— 8 —

Erase the grid lines from around the hand so that the mountains can be sketched in. The background is not an exact copy of the mountains in the reference and can be sketched in freehand. Keep them light and delicate, as this will make them look distant and misty.

— 9 —

Use tracing paper to transfer the drawing to the painting surface. Do not transfer the circular part of the magnifying glass as it would be very difficult to go over the lines in the drawing to make a perfect circle. Mark the circle out later, using a pair of compasses.

— 10 —

Cover the surface with film so that the masks for the background can be cut out. Use the two guide lines drawn previously to locate the centre of the circle and tape over this, so that the compass point does not dig in. A scalpel blade taped to the other leg of the compasses will cut a perfect circle.

———— 11 ————
Now begin airbrushing. Remove the masks from those parts of the mountains which are nearest the eye and which will be darkest in the finished artwork. Wash over these areas with grey watercolour. Only a gentle wash is needed – the colour will be built up as the adjacent areas are sprayed.

———— 12 ————
As each successive area of masking is removed, the 'layered' appearance of the mountains starts to take shape. The depth of colour in the areas of mountains exposed earlier intensifies as each coat of paint adds richness to the layers underneath.

———— 13 ————
The shading and colouring of the mountains has now been completed. The lightest areas of the mountains remain either unpainted or with very little watercolour on them, but they will look blue and misty when the sky has been airbrushed behind them.

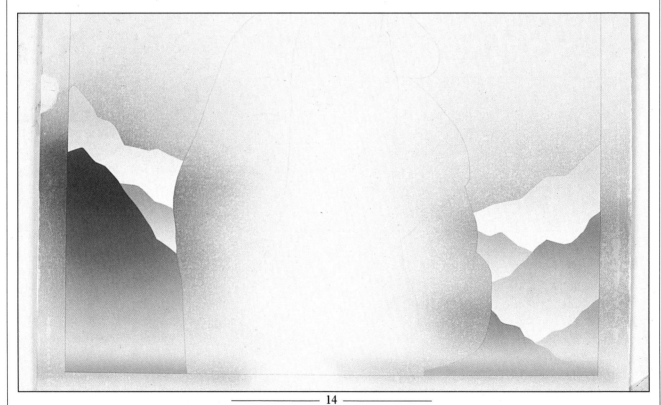

———— 14 ————
The foreground is now airbrushed using a mixture of green and grey. Only the very narrowest line of green is needed to give the impression of an outdoor scene, with grass in the foreground and mountains in the background. The green is the sort of small detail that adds interest and variety to the composition.

16

Before adding the clouds, spray a layer of gum arabic over the sky. This helps stop the blue of the sky bleeding through the white of the clouds. These were airbrushed freehand and a gentle wash of white was sprayed over the mountains to make them look slightly paler and softer.

15

Now remove the masking film from the sky and start airbrushing. Try to graduate the colour evenly, so that there is a smooth progression from light blue – almost white – at the bottom to a deeper, richer blue at the top. Notice that the tape to stop the compass point from digging in is still under the mask.

17

Now take the mask off the hand and the magnifying glass. The hand should have a new mask – the old one will have become discoloured with several layers of paint. Surround the hand with a paper mask with a window and spread a layer of masking film over this. Then cut all the lines of the hand into the masking film.

—— 18 ——
Remove the masks one at a time as the details of the hand are airbrushed, using a mixture of red, yellow ochre and sepia. Build the colour up freehand within each area of masking. It is a good idea to keep referring to the original photographic reference to make sure that the colouring looks right.

—— 19 ——
Now develop the details of the fingers. Each individual mask should be replaced after spraying to ensure that the lines remain sharp and that the colouring of the skin is not spoiled by paint falling accidentally on the wrong places.

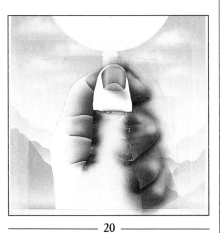

—— 20 ——
Small details, such as the shading of the thumb nail, make all the difference. They give the whole artwork a finished, professional look. The shading gives the nail a three-dimensional appearance and creates the impression of a smooth reflective surface.

—— 21 ——
The smoothly graduated areas of colour on the fleshy parts of the hand are developed by freehand spraying. At this stage, before all the masking film is peeled from the hand, it is best to make a final check against the reference photograph, to ensure the colours and shading are correct.

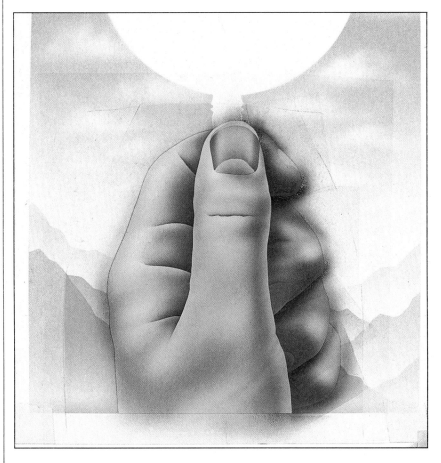

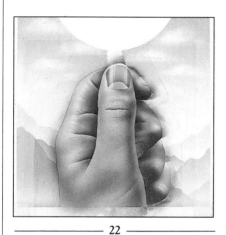

—— 22 ——

Once the masks have been taken off the hand, small details can be added to enhance the artwork. The highlights on the knuckles, the thumb, the thumb nail and index finger can be developed with an eraser and a scalpel blade. Touch in the fine lines on the flesh of the fingers, using a pencil.

—— 23 ——

Now expose the area of the magnifying glass and remask the circle and the sky. Use a paper mask to shield the rest of artwork. Follow the two guide lines to find the exact centre of the circle and protect this with tape. Use a pair of compasses fitted with a scalpel blade to cut out the concentric circles for the frame of the glass.

—— 24 ——

The darkest parts of the artwork – the frame of the magnifying glass and the sky seen through the glass – are sprayed next. Keep spraying until a black layer has developed which completely obscures the white surface. The central part of the magnifying glass is meant to look like the night sky.

—— 25 ——

Spray the lighter areas of the magnifying glass's frame and handle with grey. Start with the handle and add a little blue to the colour before airbrushing the rim of the glass. This adds a metallic look. The smooth gradation of colour on the rim makes the inner edge of the rim look bevelled.

_____ 26 _____
Now lay a new piece of masking film over the top half of the artwork and cut out the central area of the magnifying glass. Spray the white spots of the starfield with an airbrush fitted with a spatter cap. Notice how the spatter has created different sizes of spots, giving the impression of a night sky.

_____ 27 _____
The starfield looks more interesting when starburst effects and haloes are added. The shimmering small stars have faint circles of white airbrushed freehand over the original white spots. A starfield like this, with three main stars and a host of small ones, is interesting enough and does not need to be developed further.

_____ 28 _____
Finally, add a highlight to the glass to show that it has a convex surface. Remask the centre of the glass and cut out a central circle, with its circumference just inside the rim of the glass. The highlight is created with a careful wash of white, strongest around the reflection on the surface of the glass.

he Professionals

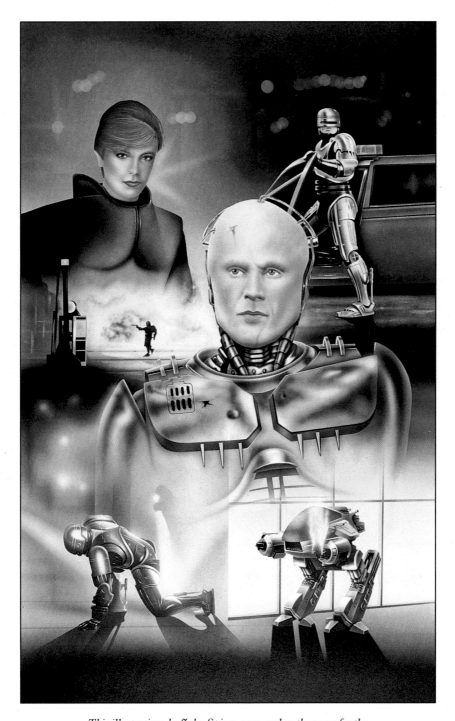

*This illustration, by John Spires, was used as the cover for the
'Robocop' video in Europe. Visual references were supplied by the
client, and then a rough drawing was produced. Once the drawing
was approved, the final artwork was created. Most of the
illustration was airbrushed, and some details were added with a
sable brush and scalpel.*

The Professionals

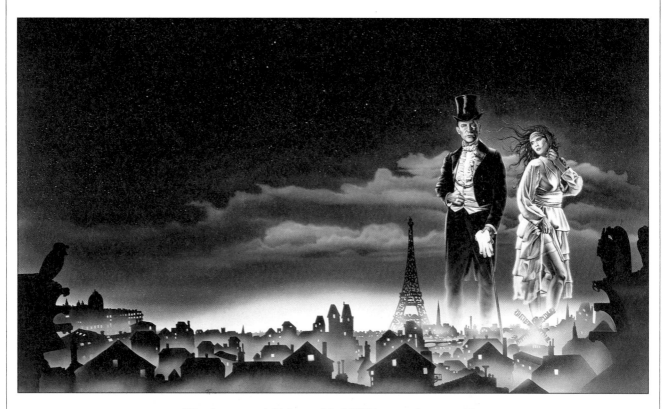

When he composed this image, Mark Wilkinson set the scene with some well-known elements of the Paris skyline, such as the Eiffel tower, and added the figures to give the illustration a surreal feeling. The gargoyles at each side of the composition frame the picture and draw the viewer's attention inwards towards the figures.

Phil Dobson airbrushed this illustration for the front cover of a piano music book. He deliberately placed the stylised pianist in an unusual setting to get away from the rigid linework which is often found on music book covers. The background, sprayed in white ink, gives depth to the picture. The raindrops were added with a sable brush.

The Professionals

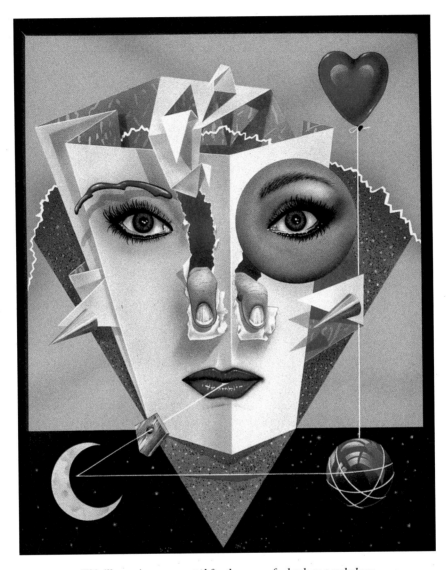

*This illustration was created for the cover of a book on psychology.
Godfrey Dowson assembled various elements that suggest a
fragmented personality. Even the effect of folded paper heightens the
unreal quality by suggesting that the face is really a mask.
Photographic references were used for the eyes, but the fingers were
drawn from life.*

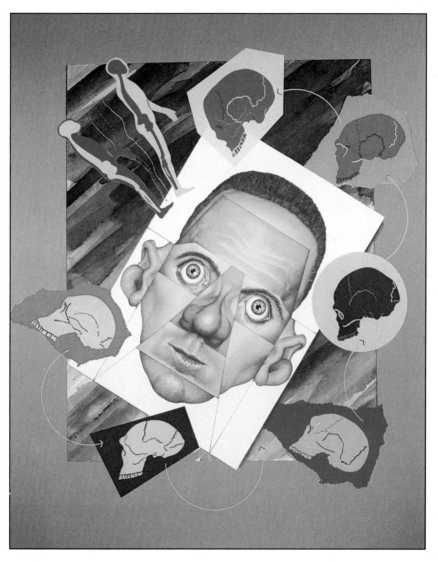

*This illustration is intended to look like a collage. Bill Prosser
completed it one section at a time, and intentionally left the lines
around the various sections clearly visible. He airbrushed the basic
tones, then used a sable brush for many of the details. Some of the
colours were developed with water-soluble pencil crayons.*

The Professionals

The client who commissioned this artwork produces slides and films on industrial medicine, and wanted an illustration which captured the essence of their business. John Spires was briefed verbally, then created this image which subsequently appeared on the client's brochure. Every detail of the illustration was masked and airbrushed.

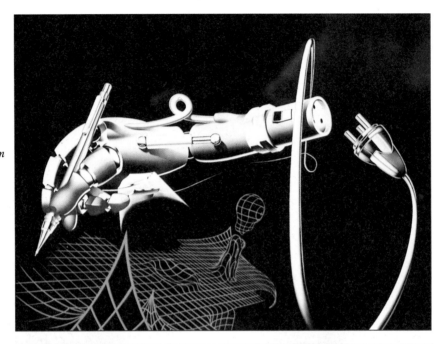

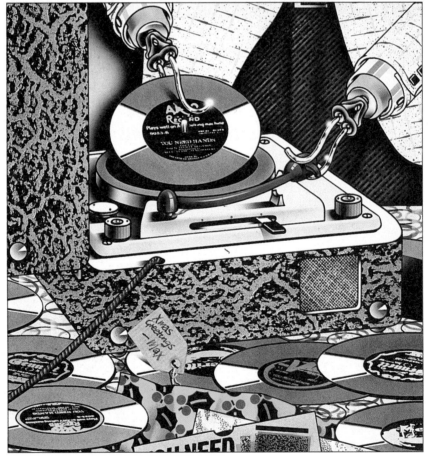

Phil Dobson submitted this artwork to the Creative Handbook, who asked for illustrations which interpreted the theme of hands. The basic fabric-like texture on the record player was achieved by dabbing the board with an old sock. The lines on the jacket were painted with a sable brush and a spatter cap was used for the red dots.

In this artwork, by Lionel Jeans, elements of reality and fantasy
have been combined in a science-fiction setting. The girl's
proportions are anatomically realistic, but she is portrayed as being
mechanical. Although the motorbike resembles real machines it also
contains imaginative, futuristic features.

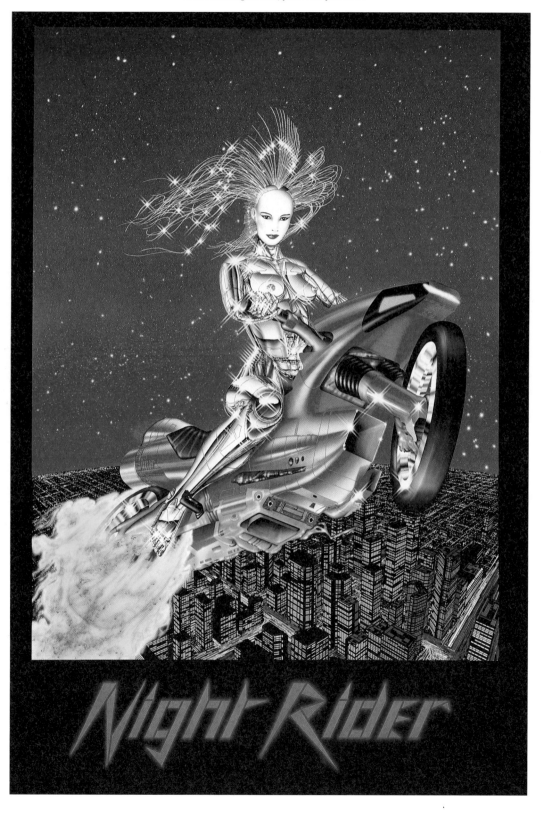

The Professionals

Andrew Stewart sprayed this image for the cover of a science fiction book. The client gave him a copy of the manuscript to read which enabled him to interpret the theme of the book in a visual form. Once the client had approved his rough drawing, he turned it into a finished artwork.

*This illustration was also used for the cover of a science fiction book
in the same series as the illustration opposite. Andrew Stewart
designed the spaceships himself and drew them out very precisely,
with every detail correct, before tracing them down onto the board.
The 'shooting stars' of fire were sprayed freehand.*

The Professionals

Godfrey Dowson airbrushed this anti-smoking campaign poster. The main image – the cigarette packet and the mouth – are set within the shape of a coffin, and there are numerous other adverse references to smoking. The statue on the left, which stands on a cigarette, has the teat of a baby's dummy for a head and is wearing a badge which shows another dummy.

The brief here was to design the cover for a book on magic. Godfrey Dowson used photographic reference for the hat and drew the gloves from life. The highlights on the lettering were scratched out with a scalpel and the luminous stars were sprayed freehand. The spatter in the background was built up by airbrushing one colour at a time.

Leather

SPRAYING ON FABRIC

Airbrushing on textiles is becoming increasingly popular, particulary for casual garments such as scarves and T-shirts. Freehand or stencilled designs can also be applied to furnishing fabrics, curtain materials and table linen, to give your home a unique personal style.

Most fabrics can be airbrushed, and craft shops now stock a wide range of liquid dyes and textile printing inks for airbrush use. Some mediums are suitable only for specific fabrics, and will not produce good results on other fabrics: if you are not sure about the compatibility of a particular ink or dye, ask your stockist or the manufacturer for advice.

Whether you decide to work freehand or to use stencils to create a repeat pattern, you should practise first of all on some off-cuts of your chosen fabric to get used to its absorbency, to work out the right colours, and to become adept at building up colour densities and gradations.

Any kind of stencil or mask (apart from liquid masking) can be used on fabric. Work with simple design shapes at first, before moving on to more complex stencils. Stencils and masks will need to be weighted down to prevent them slipping and to minimize the risk of sprayed colour creeping under them.

Airbrushed colours generally appear brighter when sprayed on to fine materials such as pure silk and fine cotton. White fabrics give the best results, as there is no risk of the sprayed colour being altered or dulled by the colour of the fabric itself.

You may find that an airbrushed item that is washed frequently begins to lose it original brightness, owing to general wear-and-tear and to the strain imposed on the fabric by the machine-washing process. Dry-cleaning is a gentler, if more expensive, cleaning process which will keep your artwork looking brighter for longer.

PREPARING THE FABRIC

Dirt, impurities and creases in the fabric will prevent the airbrushed colour from adhering firmly, resulting in an uneven appearance. Many fabrics, such as the white cotton used for T-shirts, have already been bleached, but if you are using an unbleached natural fabric, it is best to wash it thoroughly to remove any impurities that have been left in the cloth. For a really thorough cleaning

Paul Karslake sprayed this artwork onto the back of a leather jacket, building up the colours with leather inks. He used paper masks for the details in the illustration. Leather tends to stretch while you are working on it and a made-up garment is difficult to handle, but these problems can be minimised by keeping the surface as smooth as possible.

Airbrushing on fabric can be a quick and satisfying way of creating a unique
range of garments. It is made easier by the specially formulated range of
fabric colours which are now available.

process, give the fabric one machine wash cycle with
detergent, followed by another cycle without detergent.
Delicate fabrics should be hand-washed and thoroughly
rinsed.

It is best to iron out any creases in the fabric before you
begin spraying. Then pull it flat over a board, which can
be padded with felt or other material to create a really
smooth surface. Garments with a front and back, such as
skirts and T-shirts, should have a board inserted inside
them to prevent seepage through to the other side of the
garment when spraying with colour.

IRON-ON COLOURS

Another technique used with fabrics is to airbrush your
design onto a sheet of thick paper or board and then
transfer it onto the fabric. There are special inks and dyes
available for use in this way, but they are recommended
only for use with synthetic fabrics.

When the artwork is completed and thoroughly dry,
stretch the fabric over it, right side down and in the
required position, making sure there are no creases.
Cover the fabric with a sheet of stiff paper to prevent it

from sliding about, then run an iron over the stiff paper
in order to transfer the image from the original artwork
onto the fabric. The iron should be set at the hottest
possible setting that will not damage the fabric.

It is usually possible to repeat the process and make
further copies, but each successive copy from the same
painted image will be fainter than the previous one.

HEAT FIXING

To ensure colour-fast results, your design will require
heat fixing. This is done by very carefully ironing the
wrong side of the fabric when the colours have complete-
ly dried. Always read the dye manufacturer's instructions
– some may need a long exposure to heat than others.
The process of heating 'fixes' the colours to the fabric,
making them washable and able to withstand wear and
tear.

Another method of heat-fixing is to place the fabric in a
warm oven for a few minutes, loosely sandwiched
between two sheets of aluminium foil. Again, consult the
dye manufacturer's instructions regarding oven tempera-
tures and timing.

*Unlike the previous
artwork, this image
was sprayed onto a
vinyl patch which
was subsequently
stitched onto the
jacket. Paul
Karslake used paper
masks and liquid
vinyl inks, which
are actually
designed for screen
printing. The words
'Hot Stuff' were
airbrushed across
the edge of the vinyl
patch onto the
leather of the jacket.*

T-Shirt

—— 1 ——
The fabric must be completely flat before you start airbrushing, or the paint will find its way under the mask and spoil the effect. This T-shirt was ironed and spread out flat, with a piece of card between the front and the back, so that the paint would not seep through.

—— 2 ——
The colours used for this project were Badger Air-Tex water based acrylic, which are specially designed for spraying on fabrics. The T-shirt was masked with a sheet of acetate. A circle was cut out of the middle of this sheet. This circle formed a mask that would later cover the nose. Masks for the rest of the artwork were also cut out at this stage, and the red nose airbrushed.

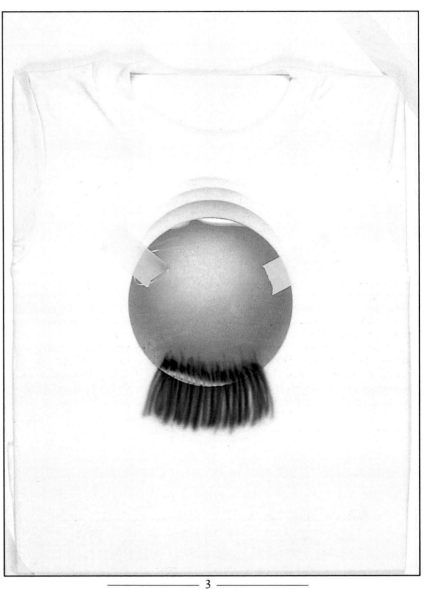

—— 3 ——
The 'bounce' lines were added to the nose by moving the acetate sheet progressively up the T-shirt and gently spraying a series of lines of red against the upper curved edge of the mask. The circular mask was then taped in position over the nose while the moustache was airbrushed on. This was done freehand, building it up line by line.

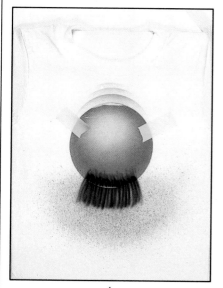

— 4 —

The next stage was to add the clown's 'blue chin'. The airbrush was fitted with its spatter cap for this effect. If you do not have a spatter cap, try turning the compressor pressure down until the airbrush begins to spatter. Loose cardboard masks were laid around the area of the chin to outline the area to be spattered.

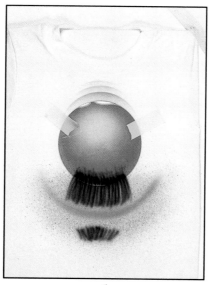

— 5 —

Like the moustache, the beard was sprayed on freehand. The mouth was also made with freehand sweeps of the airbrush. Notice how it becomes narrower towards the edges. If you are not used to spraying freehand, practise airbrushing sweeping curves on scrap paper before you actually spray onto the fabric.

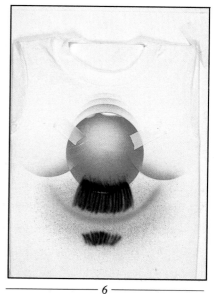

— 6 —

Keeping the circular mask in position over the nose, the acetate sheet was moved so that the circular hole lay in the right place to give a natural curve to the cheek. A gentle spray of red around the lower part of the curve created the cheek. The acetate sheet was moved and the same hole used to make the other cheek.

— 7 —

The area around the eyes was masked and black sprayed onto the upper part of the eye, and blue onto the lower part. The same colours were used for the eyebrows, which were done freehand. Remember to take extra care when you are creating highlights, as you will need to leave a light area. If you make a mistake, you cannot rub back or scratch out the colour on fabric.

Fabric Label

───────── 1 ─────────

A fabric such as binca canvas is ideal for this patch. It is tough enough to sew onto another fabric, making it your own 'designer' label. As an alternative to canvas, a heavier fabric such as demin would be suitable. It is less likely to fray than something lighter. The material must be totally flat before you begin spraying.

───────── 2 ─────────

Using Badger Air-Tex water based acrylics, gradually build up your design with a loose acetate mask. When the paint has dried on the first triangle, move the acetate mask into position for the next one. Concentrate the spray on the outermost edges of the triangles so that the intensity of the colour falls off towards the apex.

───────── 3 ─────────

When you cut the letters out of a sheet of acetate, use a ruler and a curved template as guides, so that each letter has a sharp, symmetrical, professional look. Use the acetate mask as a stencil and airbrush the letters onto the fabric. Here, the colour is most intense at the top of each letter.

4

To make the yellow vignette, mask out the whole piece of fabric and then cut out the area of the zig-zag shaped vignette, leaving the red triangles covered. Here, the yellow was sprayed more heavily around the edges of the vignette so that only a very small amount of paint fell onto the central part and the blue lettering.

Alternative Applications

These two illustrations are taken from the biggest airbrush artwork in the world – a 650 foot long mural in London's dockland. Paul Karslake and Antony Haylock used a spray gun for the larger areas and an airbrush for the fine detail. They used nitro-synthetic paint (car paint), which they sprayed onto panels of marine ply. This mural was unveiled by the minister for arts and won Paul the Evening Standard Award for The Best Hoarding in London.

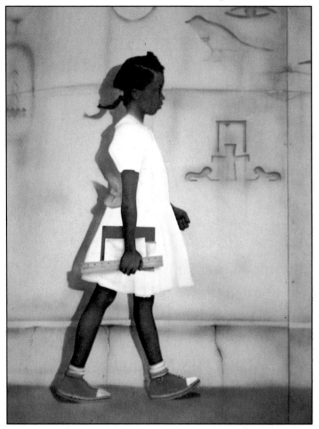
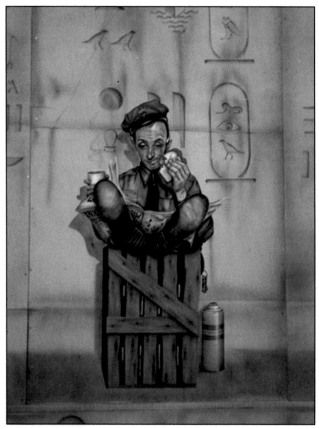

Paul Karslake airbrushed this artwork directly onto the back of a leather jacket, using paper masks and leather inks. An illustration on a leather jacket can easily suffer from wear and tear, but crazing can be reduced if it is treated with clear leather polish – sealing the image with lacquer actually increases crazing.

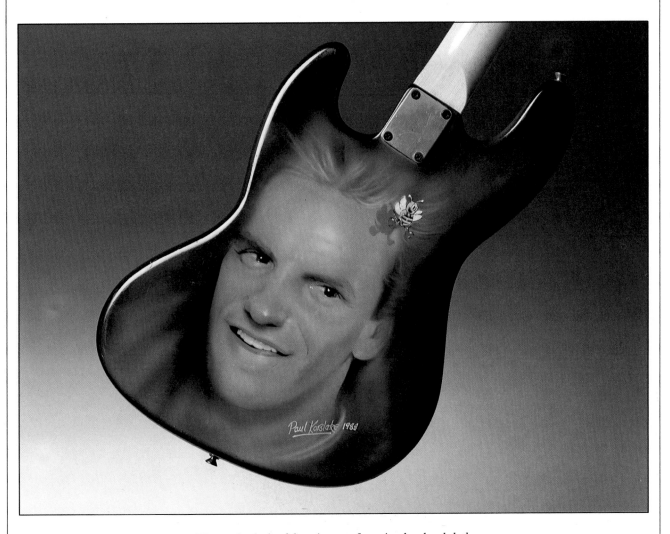

The wooden body of the guitar was first primed and sealed, then
Paul Karslake spread masking tape on the guitar, cutting the tape to
form the shapes of the artwork. Finally, the finished illustration,
which was airbrushed in acrylic, was protected against damage with
five coats of clear acrylic lacquer.

PHOTO-RETOUCHING

1

Great care was taken with the composition of this photograph so that the image of the girl and the flower would form an oval shape. The frame was supplied with an oval cardboard mask, which was used as a guide to make sure the photograph was enlarged to the correct size. The print was then dry-mounted onto board.

2

The next step was to mask the central, oval part of the photograph. The airbrushed vignette was created using opaque white. The best way of doing this is to spray from the outside of the picture towards the centre, reducing the intensity of the spray gradually as the airbrush travels across the print.

3

As the build-up of white increased, the central part of the image became more prominent. The airbrush was angled, so that the spray was directed away from the centre of the picture. The white paint, at its most intense at the edges of the picture diminishes to nothing as it approaches the central, masked area, creating the vignette.

4

This is the stage at which you can vary the sharpness of the edge of the vignette. In this case, we chose a soft edge, in keeping with the informal, relaxed style of the photograph. A sharper edge might be more suitable for a formal portrait or a scene in which the main subject had a well-defined, regular shape.

5

Once the vignette is complete, the print must be allowed to dry completely before being cut up and put into the frame. Even if it is only slightly damp, the print will stick to the underside of the glass and the whole job will be ruined. When you are cutting the print to fit the frame, make sure the oval vignette stays in the centre of the final picture.

Although photo-retouching is a highly specialised skill, the basic techniques are very useful as extremely simple images can yield professional-looking results.

──── 1 ────	──── 2 ────
The problem here is that neither the plant or the pot really stand out from the background because there is little contrast between the various shades in the picture. To overcome this, the whole print was masked and the shapes of the pot and the plant cut out. Cutting around the shapes of the leaves was a delicate job.	*With the background unmasked, a gentle wash of white was sprayed over the whole picture. You can vary the degree of contrast between the foreground and background by adjusting the amount of white that is sprayed. In this example, just enough white was sprayed to leave the colour and texture of the bricks clearly visible.*

──── 1 ────	──── 2 ────
An alternative way of retouching this picture is to make the subject of the photo stand out from the background. The original background is rather 'busy' with distracting details and highlights which lead the eye away from the girl and the flower. As a first step, the print was dry-mounted onto a piece of board.	*The picture was then covered with masking film and the shape of the girl carefully cut out leaving the background unmasked. A light even spray of transparent black was then washed over it in order to reduce the intensity of the bright, distracting areas.*

STORAGE

Having spent hours, if not days, on producing your airbrush masterpiece, it makes sense to look after it properly and to preserve it so that it will last as long as possible without deteriorating.

PROTECTING YOUR ARTWORK

As a general rule, the less handling and moving about that an artwork receives, the longer it will last without deterioration. You should always have clean hands when you handle an artwork, otherwise small quantities of natural skin oil can cause marks that are difficult or impossible to remove. That is why even a simple paper overlay – taped to the back of the artwork and folded over the front – could save an unfortunate accident. Tidiness in the studio is also important, as dirt and dust are easily transferred to your work and any unnecessary clutter can cause accidental spills.

The physical environment in which the finished artworks are stored can have an effect on their lifespan. Papers and boards tend to absorb moisture from the air over a long period of time, but they also deteriorate when they become very dry. The ideal environment for storing artworks would have a temperature of around 19 degrees Centigrade and a humidity of about 50 per cent. In any event, artworks should be kept well away from any source of direct heat such as an open fire or radiator, and in a room which is not affected by damp.

If you work with a medium such as gouache, which has a slightly powdery consistency, it is advisable to spray the finished artwork with fixative to protect it from dirt and reduce the risk of flaking. The best fixing medium for gouache is gum arabic solution – a mixture of two parts water to one part gum arabic – which can be sprayed through your airbrush. Unlike alcohol-based fixatives, gum arabic solution does not darken the colours of the finished work, and you can even work over the top of gum arabic if you wish.

After spraying with gum arabic, always flush out the airbrush quickly to prevent a film of gum drying on the needle and nozzle. This also applies to other types of fixative and varnish, which dry very quickly.

Waterproof colours, such as inks, oils and acrylics, should not require fixing, although proprietary brands of fixative are available in bottles or aerosol cans. Fixatives should always be tested on the medium and support you are using before they are used on finished work, as they have a tendency to alter some colours. Acrylic mediums can be used to spray a varnishing coat over paintings, and are available in matt or gloss finish.

Paintings done in oils should be sprayed with varnish to protect the surface – but only when the painting has completely dried (which can take months if the paint is applied thickly) otherwise the varnish dries at a different rate to the paint and may crack.

STORAGE

Over the years, you will build up a considerable collection of your own artworks. It is worth spending time and effort on keeping them in good order – the artwork you have just thrown away is usually the one that you will want to refer to again the next day!

If you have the space, a plan chest with wide, shallow drawers is the ideal place to store your artworks flat. You can also buy portfolios, specifically designed to hold papers and boards, either for storage in the studio or for transportation. As a precaution, avoid plastic portfolios, as some of these give off chemicals that can damage the artworks inside. The best portfolios are made from acid-free materials and will not exude damaging chemicals. Some contain clear plastic sleeves into which each artwork can be slid for display. These are a neat and convenient way of presenting your artworks as well as protecting them from accidents and fingermarks.

When stored, each individual artwork should be wrapped in acid-free tissue paper and separated from its neighbour by another sheet of tissue paper.

If you do not have a plan chest or portfolio in which to store your artworks, they can be wrapped in acid-free tissue paper, placed between stiff boards which are taped together around the edges, and stored vertically in a cupboard. Never roll up an artwork – the paint will probably crack and crumble when you unroll it, and you will also have trouble getting the paper to lie flat again.

Before you store away an artwork, it is a good idea to make a note of any particular colours that you mixed, any special techniques you used, and details of masking materials. Such notes are often useful for future reference.

MOUNTING AND FRAMING

Unless you have some experience of framing, this task is usually best left to a professional framer, as it requires specialist equipment and skill. But whether you frame your own artworks or not, it is useful to know something about the basic techniques of framing and mounting, as well as the aesthetic considerations of choosing the right mount and frame.

It is important to differentiate here between the terms 'mount' and 'mounting', as confusion often arises. Many artworks are surrounded by a thick card 'window' which separates the picture from the frame. This is the mount. It forms a 'breathing space' between the picture and the frame itself, enhancing the appearance and content of the work. The colour and width of the mount will affect the overall look of your painting so it is important to make a careful choice. Your frame maker will show you made-up corners in different colours and widths, which you can hold up against your picture. To avoid discolouration, always use acid-free or museum-quality mounting board.

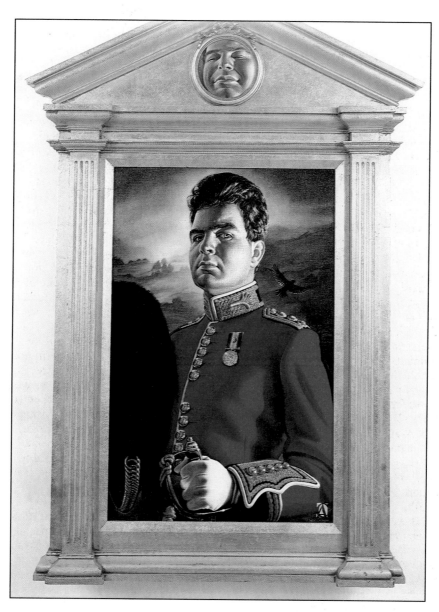

The right frame can make all the difference to the artwork! This traditional military portrait needs a 'stately home' setting – it would not look appropriate in a slim, modern frame. To add a humourous touch, Adrian Chesterman has airbrushed another small portrait of the same man in the roundel at the top of the frame.

Framing and Photography

A basic mitred, moulded wooden frame is often a good choice for showing off an illustration to its best advantage. The mitred corners of the frame help to direct the eye to the main subject of Adrian Chesterman's artwork.

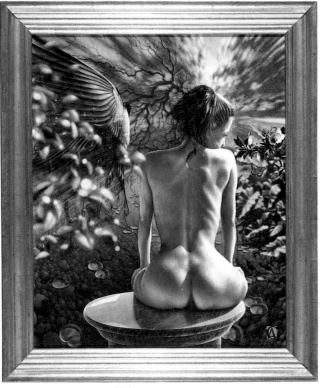

The word 'mounting' refers to the process of attaching a work done on paper to a rigid inner backing before placing it between the frame and the backing board. This gives the artwork greater strength and stability. The methods normally used for attaching the picture to the inner backing are known as 'wet mounting' and 'dry mounting'. The former involves gluing the picture to a board and the latter involves fusing the picture to the board by means of a sheet of adhesive wax film which is heat-sealed. Both of these are skilled jobs, and are normally carried out on specialist equipment, so are best left to a professional if you lack the necessary expertise.

A simpler method, and one which allows you to remove the picture from the backing at a later date if you wish, is to use narrow strips of acid-free tape, or paper hinges glued with starch paste. Do not use normal transparent tape or solid adhesives for this purpose, as they are too strongly adhesive and will eventually cause discolouration and decay of the paper. Fold the tape back onto itself as you would with stamps in an album and attach it to the back of the artwork, as close to the edges as possible, then press on the inner backing board.

When choosing a frame for your picture, you need to consider its width, colour and design in relation to the image itself. Ready-made framers' moulding is available in a bewildering array of types and finishes; a profession-al framer will give you advice on choosing a frame that is right for the subject, colour and style of your painting.

Paintings done in delicate media such as watercolour or gouache need to be framed behind glass to protect them from dirt and damp. There are two kinds of glass to choose from – ordinary and non-reflective. Although ordinary glass can cause annoying reflections under certain lighting conditions, it is generally preferable to non-reflective glass: this is more expensive to buy, and tends to cast a matt sheen over the picture.

If possible, pictures should be hung on a wall well away from the path of direct sunlight, which can cause some pigments to fade. Heat can seriously damage the surface of paintings, so avoid placing them directly above heaters if they are unglazed. Finally, it goes without saying that artworks should be kept free of damp and condensation.

PHOTOGRAPHING YOUR WORK

If you intend to show or sell your pictures, you will find it useful to keep a photographic record of your work. Good slides of your best work can be instrumental in obtaining a commission, winning a competition or making a sale. If you sell or make a gift of an artwork, you'll want a good photograph of it for your own records. You can make multiple prints to send to prospective clients, who may want to reproduce the artwork from your transparency rather than from the artwork. It is also much easier to transport transparencies and avoids any damage to an artwork in transit. Clearly, your photographs need to be of the best possible quality to show your work to advantage.

The best camera for photographing artworks is a single-lens reflex (SLR) camera that allows you manual control over lens aperture and shutter speed. The compact, fully automatic 35mm snapshot cameras that are popular now are not ideally suited to photographing artwork, as they offer little or no exposure control.

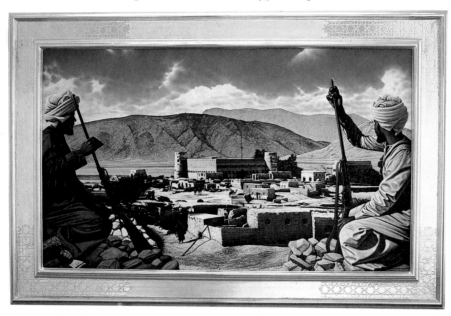

Modern cameras and films produce very good quality results, and a 35mm transparency will be acceptable to most agencies, picture libraries and publishers. However, a larger format is preferable if you have access to a suitable camera. Many professional photographers use medium-format cameras that produce transparencies of 6 x 4.5cm, 6 x 6cm, or 6 x 7cm. The greater size of a medium format transparency makes the picture easier to view when placed on a light box, and a larger transparency can be enlarged to a greater size before the resulting image begins to look grainy.

It is best to use films that produce transparencies rather than negatives, because many colour reproduction techniques involved in publishing use transparencies as the source of their colour images. In any case, a professional photographic laboratory will make you a good quality colour print from your transparency.

You will also need a tripod, which can be bought, rented or borrowed from a friend, to hold your camera in a fixed position. This is very important, because a hand-held camera, even in the steadiest of hands, is subject to camera movement, or 'shake', and this will reduce the sharpness of the image considerably.

A cable release is a useful accessory, as it allows you to trip the camera shutter without the risk of camera shake during the relatively long exposure time required for photographing artworks.

If you prefer to photograph your artwork horizontally, rather than propping it against a wall, you will find a copy stand useful. This consists of a stable baseboard with a vertical rail attached at the back; you mount the camera, lens down, on a bar connected to the rail. The bar can be moved up or down the rail to adjust for different-sized artwork. You can rapidly photograph a succession of pictures, sliding them under the camera one after the other. Some copy stands also have attachements that hold one or two flash units.

Flat artwork should ideally be lit by a single lamp on either side. The lamps should be placed at a height corresponding to a point midway up the artwork, and set at an angle of 45 degrees from the artwork. If they are placed at too steep an angle, they may cause glare on the sides of the work; if placed at too shallow an angle, the light may be uneven.

When you have set up your camera equipment and established the correct exposure and shutter speed, make sure you have focused properly and that the artwork is centred in the viewfinder. Shoot as many slides as you think you will need: it is easier, quicker and cheaper to take a number of identical shots than to have transparencies copied at a later date or to set up the camera equipment again for another photo session. Likewise, it is advisable to 'bracket' your exposures. Shoot three frames, one at the chosen exposure, one a stop lighter and one a stop darker. For example, shoot one frame at the f11 setting, one at f8 (lighter) and one at f16 (darker). These extra, 'insurance' frames should guarantee you at least one picture at the correct exposure.

If you do not wish to go to the trouble of photographing your work, but still wish to keep a visual record, a colour photocopy is an acceptable way of making such a record. Good-quality copiers are now widely available, and for only a small outlay you can get a reasonable reproduction of your work.

INDEX

*Page numbers in italic refer to captions and
illustrations*

p6 Tom Stimpson, courtesy of Aircraft; **p7** *left*: Gavin McCleod, courtesy of Meiklejohn Illustration; *right*: Brian Robson, courtesy of Meiklejohn Illustration; *bottom*: Andrew Stewart, courtesy of Artists Incorporated; **p21** Pete Kelly, courtesy of Meiklejohn Illustration; **p32** *left & right*: David Holmes; *bottom*: Pete Kelly all courtesy of Meiklejohn Illustration; **p33** Godfrey Dowson; **p34** Pete Kelly, courtesy of Meiklejohn Illustration; **p35** David Bull © Image Bank; **p41** *top*: Nick Farmer, courtesy of Aart; *bottom*: Alfons Kiefer; **pp42-43** Adrian Chesterman, courtesy of Aart; **p44** *top*: Doug Gray; *bottom*: Andrew Farley, courtesy of Meiklejohn Illustration; **p45** *top*: Andrew Farley, courtesy of Meiklejohn Illustration; *bottom*: Godfrey Dowson; **pp50–51** John Charles; **p52** Jon Rogers, courtesy of Ian Fleming; **p53** Pete Kelly, courtesy of Meiklejohn Illustration; **p54** Peter Beavis, courtesy of Aart; **p55** Malcolm Smith, courtesy of Ian Fleming; **p59** Ian Southwood, courtesy of Artists Incorporated; **p60** Andrew Farley; **p61** Pete Kelly, both courtesy of Meiklejohn Illustration; **p62** Malcolm Smith, courtesy of Ian Fleming; **p63** Doug Gray; **p64** *top*: Jonathan Minshull, courtesy of Artists Incorporated; *bottom*: Doug Gray; **p65** Barry Mitchell, courtesy of Ian Fleming; **pp66–67** Ian Southwood, courtesy of Artists Incorporated; **p68** Pete Kelly, courtesy of Meiklejohn Illustration; **p69** Jon Rogers, courtesy of Ian Fleming; **p70** Ian Southwood, courtesy of Artists Incorporated; **p71** Nigel Tidman, courtesy of Meiklejohn Illustration; **p72** Pete Kelly; **p73** Jerry Preston, both courtesy of Meiklejohn Illustration; **pp74–75** David Bull; **p74** © Image Bank; **p76** Mark Wilkinson; **p77** Chris Burke, courtesy of Aart; **p79** Ian Southwood, courtesy of Artists Incorporated; **p82** Gavin McCleod, courtesy of Meiklejohn Illustration; **p83** Chris Burke, courtesy of Aart; **p89** Andrew Farley, courtesy of Meiklejohn Illustration; **p90** Ian Southwood; **p91** Andrew Stewart, both courtesy of Artists Incorporated; **p92** Nigel Tidman, courtesy of Meiklejohn Illustration; **p93** Doug Gray; **pp94–95** Nick Farmer, courtesy of Aart; **p100** Paul Higgens, courtesy of Ian Fleming; **p101** John Harwood; **pp102–103** *top*: Keith Hume © Bournemouth & Poole College of Art & Design; **p103** Paul Higgens, courtesy of Ian Fleming; **p104** *top*: Keith Hume © Bournemouth & Poole College of Art & Design; **pp104–105** *top*: Paul Higgens, courtesy of Ian Fleming; **p 105** Nick Farmer, courtesy of Aart; **p106** Jon Rogers, courtesy of Ian Fleming; **p107** Phil Dobson, courtesy of Aart; **p 108** Jon Rogers, courtesy of Ian Fleming; **p109** Ainslie McCleod; **p 117** John Spires, courtesy of Artists Incorporated; **p118** Mark Wilkinson; **p119** Phil Dobson, courtesy of Aart; **p120** Godfrey Dowson; **p121** Bill Prosser; **p122** *top*: John Spires, courtesy of Artists Incorporated; *bottom*: Phil Dobson; **p123** Lionel Jeans; **pp124–125** Andrew Stewart, courtesy of Artists Incorporated; **pp126–127** Godfrey Dowson; **pp128–129** Paul Karslake; **pp134–135** Paul Karslake; **pp136–137** photographs by Andy Charlesworth; **pp139–140** Adrian Chesterman, courtesy of Aart; **p 141** Ian Southwood, courtesy of Artists Incorporated.

All step-by-steps and photography throughout the book by Mark Taylor. Equipment photography: Piers Bizony.

With special thanks to Langford & Hill Ltd, London W1, for supplying all the equipment as well as Aztec and De Vilbiss.